POSTCARD HISTORY SERIES

Fort Wayne

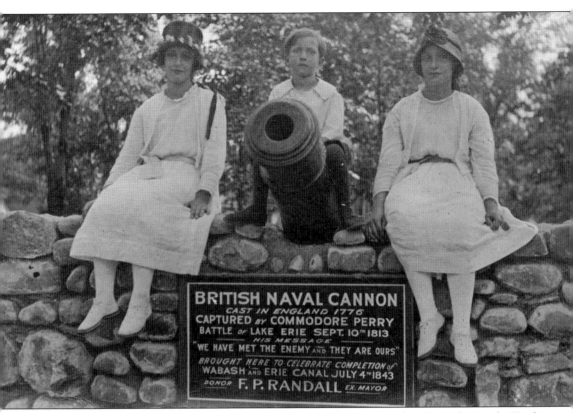

This 1776 English cannon, as the sign states, was captured by Commodore Perry during the Battle of Lake Erie in 1813 and was brought to Fort Wayne to help celebrate the July 4, 1843, completion of the Wabash & Erie Canal. Donated by the family of former mayor Franklin P. Randall, the cannon now sits just inside the entrance of the History Center on East Berry Street.

ON THE FRONT COVER: This c. 1935 aerial real-photo postcard of downtown offers a vibrant view of the crowded central business district, devoid of today's numerous parking lots, with the 1902 courthouse and the 1930 Lincoln Tower at its core.

ON THE BACK COVER: Taken around 1910, this photograph shows a group of Robison Park visitors standing behind painted scenery, ostensibly "going to Ft. Wayne." Photographer Norman P. Standish maintained a studio at the park and had several such novelty set pieces available for group photographs. Interestingly enough, one could actually travel by boat from the park via the adjacent St. Joe River to downtown Fort Wayne, six miles away.

POSTCARD HISTORY SERIES

Fort Wayne

Randolph L. Harter

ARCADIA
PUBLISHING

Published by Arcadia Publishing
Charleston, South Carolina

Printed in the United States of America

Library of Congress Control Number: 2013934863

For all general information contact Arcadia Publishing at:
Telephone 843-853-2070
Fax 843-853-0044
E-mail sales@arcadiapublishing.com
For customer service and orders:
Toll-Free 1-888-313-2665

Visit us on the Internet at www.arcadiapublishing.com

For Mom and Dad, Pat, Nick, Sarah,
and so future generations can know.
For Dylan, Samantha, Caroline, and Marlena,
here you go.

CONTENTS

ACKNOWLEDGMENTS

I would like to thank my fellow Fort Wayne deltiologists—Jeanette Reitz, Jane Lyle, Todd Baron, Gene Branning, and Craig Leonard—who let me peruse their collections and choose some of their rare postcards for inclusion in this book. Thanks also go to John Hornberger, who photographed Powers Hamburgers and the Embassy and gave permission to use the resulting postcards herein. Unless otherwise credited, all other postcards shown are courtesy of the Randolph L. and Patricia K. Harter Postcard Collection at the Allen County Public Library.

In unearthing facts and tidbits about Fort Wayne's past, I was assisted by three of the city's living treasure troves of local history information. Thanks go to John D. Beatty, Allen County Public Library Genealogy Center reference librarian; Walter Font, History Center curator; and Craig Leonard, historic preservation consultant.

In addition to those resources listed in the bibliography, the following were consulted either directly or through their past written materials: Richard L. Schory, Coley D. Arnold, Tom Castaldi, Jim and Kathy Barron, Dodie Marie Miller, Gerald Gaff, John A. Hoffman, James Schaab, Dyne Pfeffenberger, Ralph Violette, Chad Gramling, John Martin Smith, Casey Drudge, Geoff Paddock, Angela Quinn, Alan Gaff, William C. Lee, Julie Donnell, John Stafford, Walter Sassmannshausen, Don Werling, William Decker, Clovis Linkous, and numerous articles and other publications written by professionals at the History Center, Allen County Public Library, the *New Sentinel*, and the *Journal-Gazette*. The Internet also played a large part with research, as nearly 100 company, organizational, and state- and local-government websites were consulted.

This book would not exist were it not for a sunny summer day when I stopped in Joel Hyde's used-book store, Every Other Book, looking for new (to me) old Fort Wayne history books. I happened to ask Mr. Hyde if he ever got in any old local postcards. After he quizzically answered "no," I proceeded to tell him I had been a 35-year-plus collector of vintage Fort Wayne postcards and now had nearly 3,000 different examples. To this he replied, "That's a book!" And so now it is. Thanks, Joel.

Lastly, to my postcard-collecting-trips partner, editor, and wife of 37 years, Patricia K. Harter, much love.

INTRODUCTION

Picture postcards first became popular when they were produced for the 1893 World's Columbian Exposition in Chicago. Their golden age was between 1907 and 1915, a time when very few people had telephones. Thus, postcards, which only required a 1¢ stamp, acted as a way to inexpensively and quickly communicate with someone either hundreds of miles away or just across town. In an era when travel was limited and television nonexistent, the picture postcards allowed people to vicariously visit other cities and countries without leaving their homes. The US Postal Service estimates that, in 1913, when the population of the United States was just 95 million people, 968,000,000 postcards were mailed—roughly 10 for every man, woman, and child. Many of these were then collected and put proudly into postcard albums, as was the norm at the time.

Besides the mass-produced postcards, nearly every community of any size had a local photography studio. In 1913, there were over a dozen in Fort Wayne, and several of them also produced postcards as a supplement to their normal studio business. These cards are referred to as real-photo postcards and in some cases only one or a handful of a specific image were produced, making them both rare and highly sought-after by today's collectors. Such postcards have been used in this book wherever possible, especially in the "Disastrous Days" chapter, which exclusively includes real-photo postcards produced by local photographers. These would have been quickly produced and sold in local stores on the day of an event or shortly thereafter. As Walter Font, curator at the Fort Wayne History Center, once told me, "In many cases the only image of a local event, structure, or vista is from an early postcard." Therefore, postcards are important links to our past for both professional researchers as well as casual history buffs such as myself.

The challenge in compiling this book was not a lack of images, even though it was limited to only pictures that were from postcards. With the help of other local postcard collectors (deltiologists), I had more than 3,500 different Fort Wayne images from which to choose. The issue was really more in showing a representative view of our beautiful and storied city while keeping it to a scant 225-plus pictures. A lot of wonderful images did not make the cut, and in many other cases, a postcard was either never made or was not available to illustrate a specific subject.

My hope is that, for many of you, these images will bring back fond memories and offer fresh information that further spurs interest in your own families and Fort Wayne's colorful history.

One

ACTIVITIES ABOUND

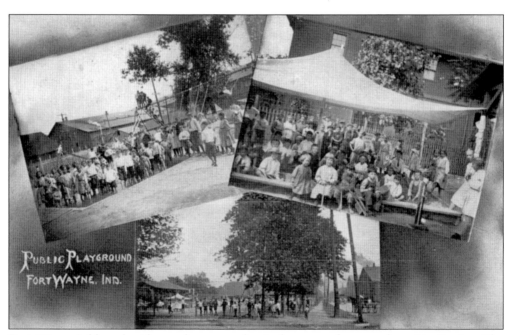

Fort Wayne is blessed with a parks system that is the envy of many other cities its size. The Holman playground, pictured here in 1910, was one of several playgrounds. While it did not measure up to typical park size, it was, nonetheless, important for children of that time. This playground at the corner of Holman (today's East Brackenridge) and South Clinton Streets is now the site of the main post office.

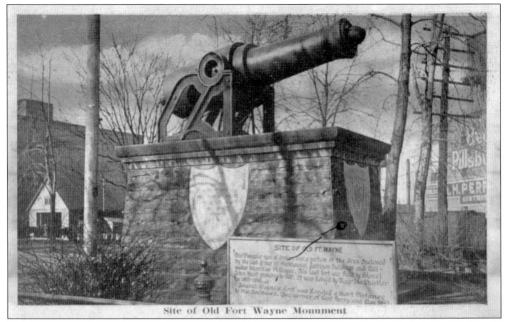

Site of Old Fort Wayne Monument

Fort Wayne's oldest park, Old Fort Park, was the beginning of the park system in 1863. This small triangular plot of land is located on East Main Street near its intersection with Clay Street and was the site of the 1816 fort commonly known as "Whistler's Fort." The reproduction of this fort sits today on Spy Run Avenue.

Central View McCulloch Park, Fort Wayne, Ind.

McCulloch Park was the first park donated to the city, a gift from Hugh McCulloch and his wife, Susan. This ground was originally the City Cemetery (also called Broadway Cemetery), which had outgrown the location by the mid-1800s. With the exception of the grave of former governor Samuel Bigger, the deceased were disinterred and moved to the new Lindenwood Cemetery in the 1860s.

Joining the park system in 1866, Lawton Park was originally called Northside Park but was renamed in honor of Gen. Henry W. Lawton, the first local citizen to receive the Congressional Medal of Honor (in recognition of his actions during the Civil War). This monument, dedicated in 1900, commemorates General Lawton, who was killed while leading a 4,000-man army on Luzon, Philippines, in 1899.

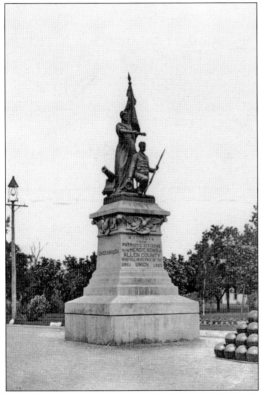

This Civil War monument, located in Lawton Park on the Spy Run side and dedicated in 1893, was largely paid for by the Centlivre Brewing family. It reads, "A tribute from patriotic citizens to the heroic sons of Allen County who fell in defense of the Union 1861–1865." This bronze work is the oldest statue on public property in Fort Wayne.

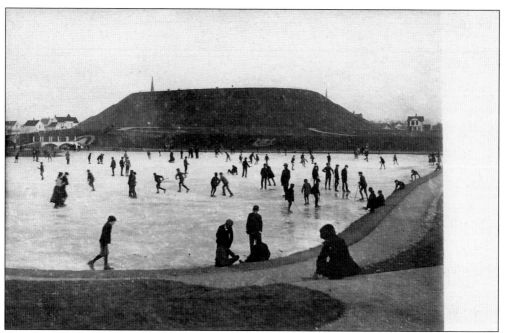

Reservoir Park came into being in 1880—a time when the population of the city was nearly 27,000—as the answer to the need for a more dependable and pressurized water flow for the city's drinking and firefighting outlets. Water from deep rock wells was pumped into the man-made reservoir and then delivered to homes via gravity. (Courtesy of Jeanette Reitz.)

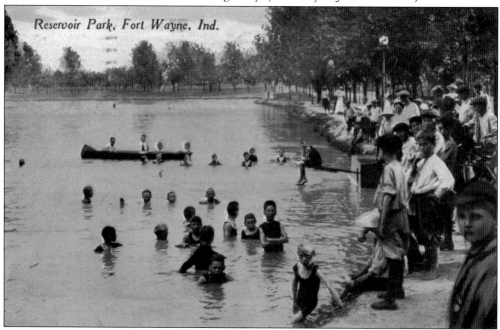

A wooden cap was made that covered the whole top of the hill. Since then, in both winter and summer, the children of Fort Wayne have been enjoying the lake excavated to provide the dirt for the reservoir hillsides. In 1959, the hollowed-out reservoir, no longer necessary, was filled in. This resulted in the height of the hill being lowered as the top was used for the fill.

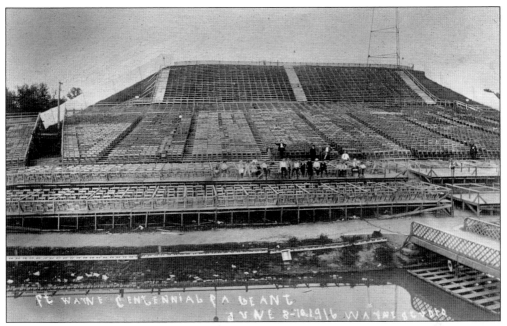

The seating and pylon-flanked stage required for the pageant grounds built at Reservoir Park in 1916 were arguably the largest temporary construction project ever undertaken in the city. Created to celebrate the 100th anniversary of Indiana's admission into the Union, the pageant was called "the Glorious Gateway of the West."

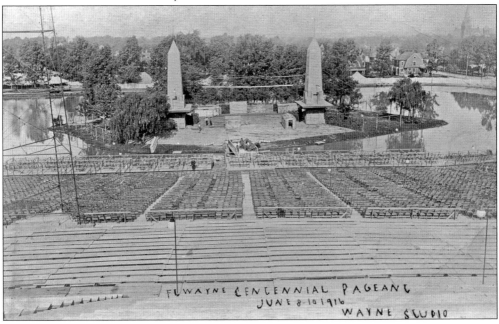

Designed to hold 14,000 people, the seating was built at the base and up the side of the reservoir itself. Over 1,000 local citizens participated in the play, which illustrated various periods and scenes from Fort Wayne's past. Parades and arches over some of the streets downtown also were part of the celebration, which ran from June 5 to June 10, as was a large industrial exhibition in the area of the current Headwaters Park.

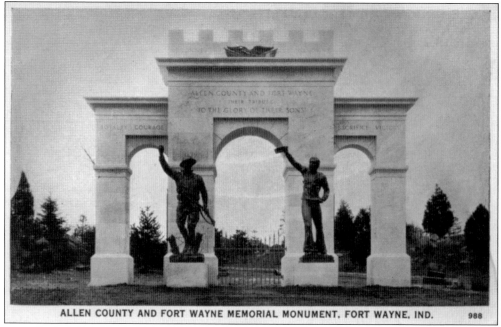

ALLEN COUNTY AND FORT WAYNE MEMORIAL MONUMENT, FORT WAYNE, IND. 988

The grounds for Memorial Park, consisting of 42 acres, were purchased in 1918. The park is named in honor of the local servicemen and women who died during World War I. In addition to the names of the deceased on the memorial, dedicated in 1920, is a statue of an American doughboy and a Navy corpsman.

McMillen Park came into being in 1937 with a land gift from local industrialist Dale W. McMillen. McMillen, who founded Central Soya and was known as "Mr. Mac," also founded and funded the Wildcat League baseball program, which continues to this day and allows all children who want to play baseball to participate. He, his family, and his foundation donated additional funds to the park in subsequent years.

VIEW IN SUNKEN GARDENS IN LAKESIDE PARK, FORT WAYNE, IND. 1A2530

In 1908, the first parcel of land that was to become the beautiful Lakeside Park and Rose Gardens was purchased. Gifts from the Forest Park Company in 1908 and 1912 would bring the park to its current 23 acres. The Delta Lakes were excavated to provide material for river diking around the Lakeside neighborhood, which was developed in 1890.

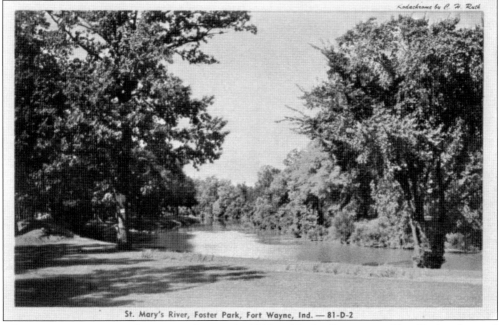

St. Mary's River, Foster Park, Fort Wayne, Ind. — 81-D-2

The expansive Foster Park came to the city in 1912, with the first tracts of land being donated by brothers Samuel and David Foster. The park consists of 255 acres and now includes a golf course, tennis courts, picnic pavilions, and a replica of the cabin in which Abraham Lincoln was born, donated by Lincoln National Life Insurance Company.

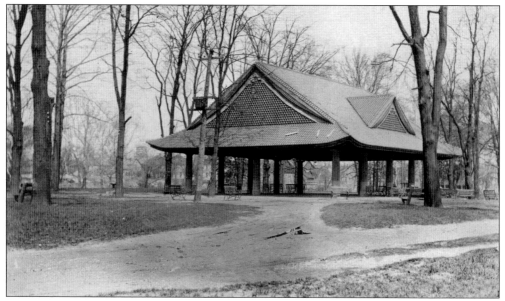

The first acreage for Swinney Park, including the Swinney Homestead, came to the city as a posthumous gift from Col. Thomas Swinney. The still-standing 1844 homestead was, from 1926 through 1979, home to the Allen County–Fort Wayne Historical Museum. This postcard image is of the original pagoda pavilion that was part of the park's beautiful Japanese Gardens. Although it is now gone, a modern, stylized replica has recently replaced it.

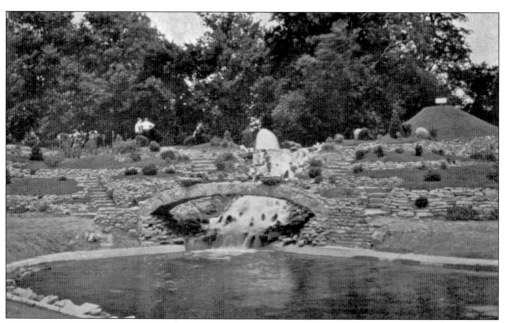

Swinney Park has had many uses over the years, including being the Allen County Fairgrounds with a half-mile horserace track. Pictured is part of the Japanese Gardens at Swinney Park. These were renamed Jaenicke Gardens for the designer, park superintendent Adolph Jaenicke, in May 1942 as a result of public sentiment following the Japanese attack on Pearl Harbor.

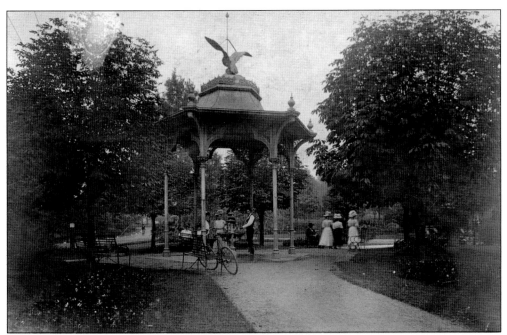

This idyllic pavilion with large eagle on top and water fountain centered below was located at the northeast corner of the courthouse square until December 1896. With construction soon to start on the new, larger courthouse, which would take up the whole square block, it was moved and re-erected at this spot in Swinney Park in April 1897.

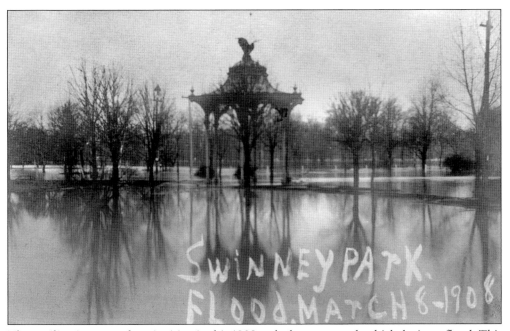

The pavilion is not nearly so inviting in this 1908 real-photo postcard, which depicts a flood. This was one of many floods throughout the years that would affect city parks, especially Swinney and Foster because of their low elevation and proximity to the St. Mary's River.

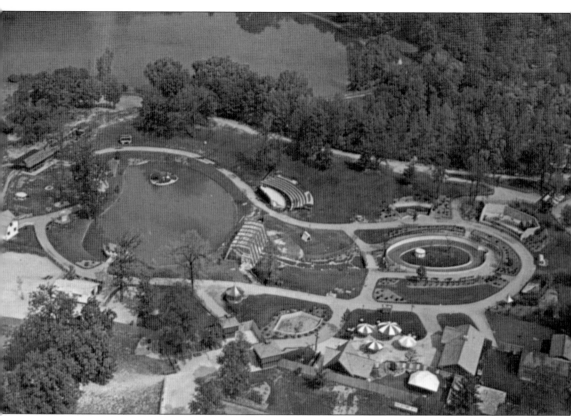

The initial gift of 80 acres from John B. Franke, the founder of Perfection Biscuit Company, became Fort Wayne's largest park, Franke Park, in 1921. With additional gifts and acquisitions over the years, including Fred B. Shoaff's donation of another 54 acres in 1952, Franke Park would come to include the Franke Day Camp (1946), Shoaff Lake (1947), Foellinger Theatre (1949), and Children's Zoo (1965). Pictured is an early aerial view of the zoo from around 1970. Under the zoo's first director, Earl B. Wells (hired in 1964), and with the help of philanthropic gifts, the Fort Wayne Children's Zoo would continue to grow and prosper. Jim Anderson became the new director when Wells retired in 1994. With over 500,000 visitors per year, the zoo receives no tax funding and is entirely self-supporting through its self-generated revenue and donations.

Constructed in Franke Park in 1963, the Jack D. Diehm Memorial Museum of Natural History was donated by local taxidermist Berlen Diehm and his wife, Violet, in memory of their deceased son Jack. Sadly, it was destroyed by arsonists in 1975 and a new museum was built on Franke Park Drive in 1981 featuring dioramas narrated by local broadcaster Bob Sievers. It closed in 2012. Pictured above is the earlier 1963 museum.

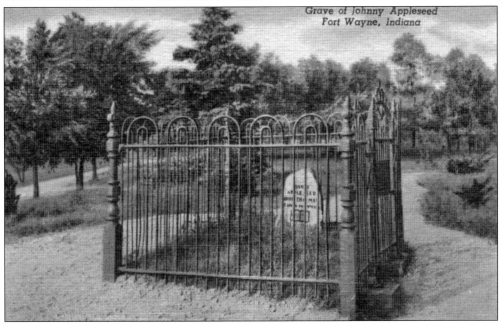

A marker and memorial to John Chapman, better known as "Johnny Appleseed," was placed atop this hill in Johnny Appleseed Park in 1916. While the exact location of his gravesite is lost to time, this property was part of the Archer Farm where he is said to have been interred in 1845, at 71 years of age. His life and work have been celebrated with the Johnny Appleseed Festival in this park every year since 1975.

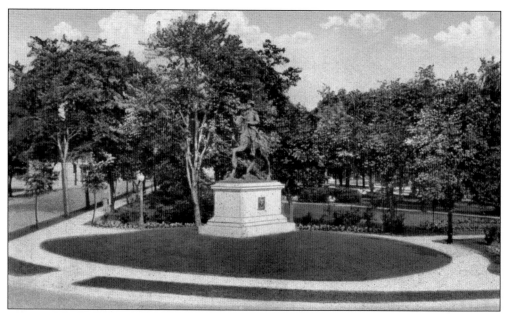

This statue of Gen. Anthony Wayne astride his horse was first located here in Hayden Park, on Maumee at Harmer Streets, upon its completion by Chicago sculptor George E. Ganiere in 1916. It was moved to Freimann Square in 1973. The one-and-a-half-acre Hayden Park has since been renamed Nuckols Park in memory of the city's first African American city councilman, John Nuckols.

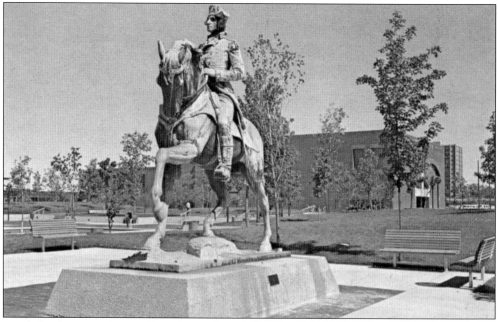

Funded in large part by a posthumous donation from Frank Freimann, the four-and-a-half-acre Freimann Square with fountains and the relocated equestrian statue of Gen. Anthony Wayne is a favorite lunchtime spot in the downtown area. Freimann was a pioneer in the field of electronic sound and chief executive officer of Magnavox for 18 years. Freimann professorships are awarded in engineering and physics at Notre Dame and were the school's first endowed chairs.

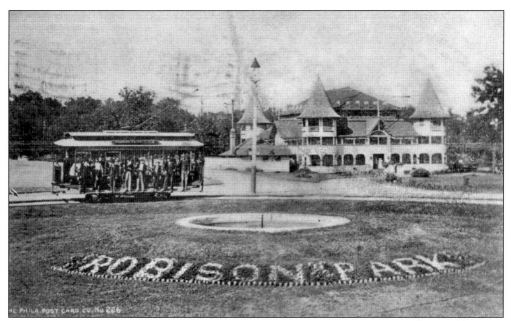

Robison Park was opened seven miles north of the city, along the St. Joe River, in 1896. At this location a dam was built in 1832 to provide water for the feeder canal, which ran from just below the park to where it intersected with the Wabash & Erie Canal off West Main Street. The backed-up river created deep lagoons, around which the park was built. Pictured are the castle-like main pavilion and the trolley turnaround.

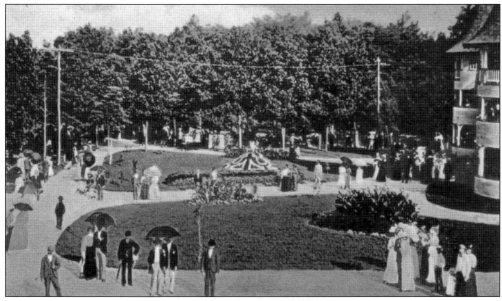

The Fort Wayne Consolidated Railway Company, which built the park, charged a 20¢ roundtrip fee to ride their trolleys from downtown. Guests would find a number of attractions, including picnic grounds, dancing in the main pavilion's ballroom, a shooting gallery, an ice-cream stand, a theater, a bowling alley, a hall of mirrors, and a carousel. On opening day, an estimated 8,000 people rode the trolleys to the park.

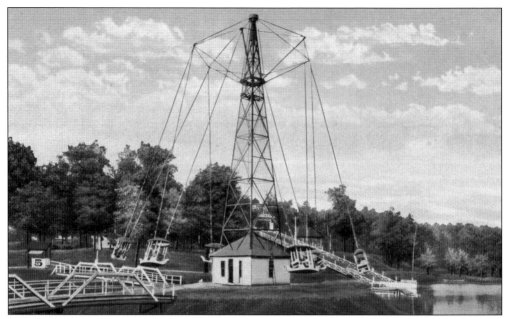

The 60-foot-high Circle Swing tower, set on an island in the main lagoon, was accessed by rustic wooden bridges. Turning slowly at first, the six gondolas would later rise to about 20 feet off the water. The site of the park today makes up the back section of the North Point Woods addition on North Clinton Street and is across the river from the back of River Bend Golf Course.

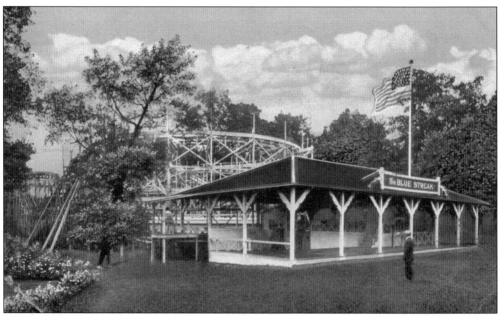

One of the attractions that would live on past the park's demise was the double-figure-eight Blue Streak roller coaster. It would later be dismantled and installed at Trier's Park in West Swinney Park, where it was renamed the Cyclone. Robison Park, as well as the trolley line, had several owners, including Fort Wayne & Wabash Valley Traction Company and the Fort Wayne & Northern Indiana Traction Company.

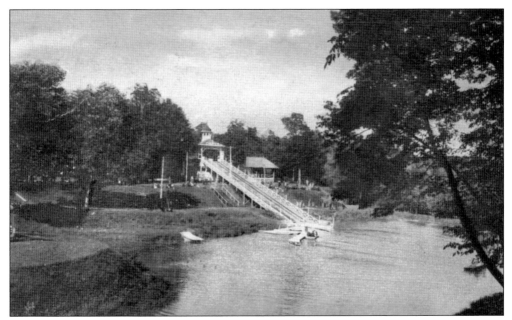

Shoot the Chutes consisted of a 60-foot-high wooden tower on the bluff with a channeled double ramp that extended down and into the water below. Six-person, flat-bottom wooden boats were winched to the tower above and then loaded with thrill seekers for a screaming ride down the ramp and partially across the lagoon.

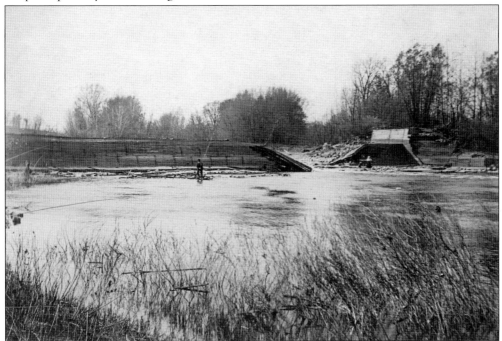

A series of high-water events and floods badly weakened the nearly 80-year-old dam. No longer required to supply water for the Wabash & Erie Canal (which had shut down in the mid-1870s), the dam was not rebuilt once it gave way. The lowered water level in Robison Park, along with other economic changes, resulted in the park's closing at the end of the 1919 season.

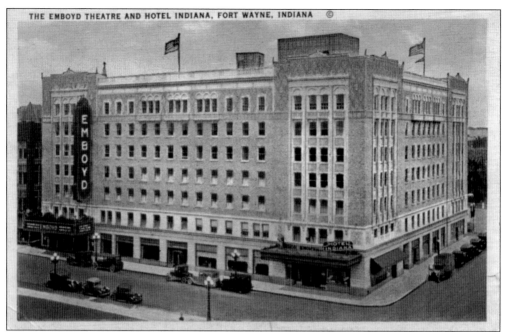

Built by the Fox Realty Company and operated by W. Clyde Quimby, the Embassy Theatre opened as the Emboyd in the spring of 1928, changing its name to the Embassy in 1952. The main theater room measures 100 feet wide and 140 feet deep with a height of 80 feet from the floor to the main dome, and the facility was the first "air cooled" public building in Fort Wayne.

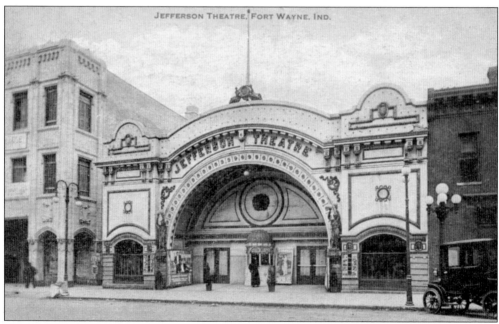

Built in 1912 at 116–118 West Jefferson Boulevard, the Jefferson Theatre was virtually across the street from the Embassy, which was at 123 West Jefferson. The front of the theater would later resemble the Embassy, with a large protruding marquee over the sidewalk listing the current offerings. The Grand Wayne Convention Center is now located on this site.

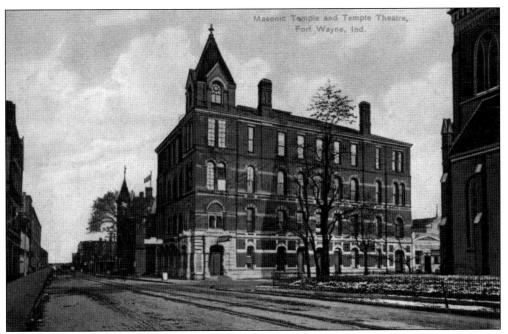

The Temple Theatre was completed in 1884 at the northeast corner of Clinton and Wayne Streets where today one would find the Citizens Square building (formerly W&D's). With a capacity of approximately 1,000 seats, the theater engaged vaudeville acts, singers, and orators before its destruction by fire in 1923.

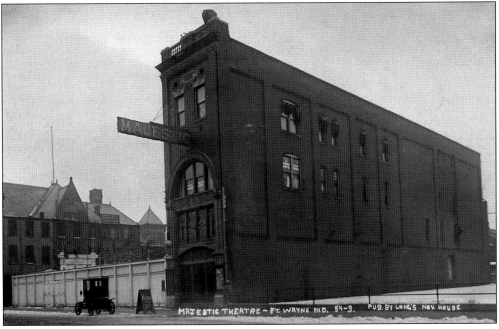

The Majestic Theatre opened in 1904 at 216 East Berry, on the south side of Berry Street between Barr and Clinton Streets. For over 30 years, the theater was home to the Old Fort Players, the group known today as the Civic Theatre. The Majestic was torn down in 1957, and the location is now the site of the Citizen Square parking lot. (Courtesy of Gene Branning.)

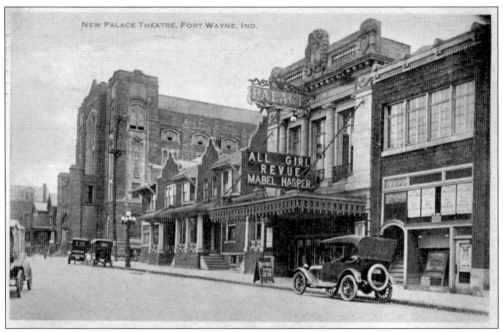

The Palace Theatre opened in 1915 at 126 West Washington, west of Clinton Street, with seating for 2,000 people. Later home to the Civic Theatre, it was renamed the Civic Playhouse before the Civic moved to the Maiden Lane Theatre (old Elks Hall) in 1969. Demolished in 1971, it is now the site of the Grand Wayne Convention Center parking garage.

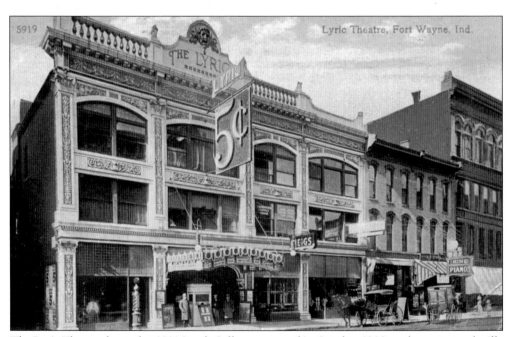

The Lyric Theatre, located at 1014 South Calhoun, opened in October 1908 as a home to vaudeville acts and movies. In the 1920s, it became a burlesque house known as the Riley Theatre; it later became a movie house again. The building was razed in 1961.

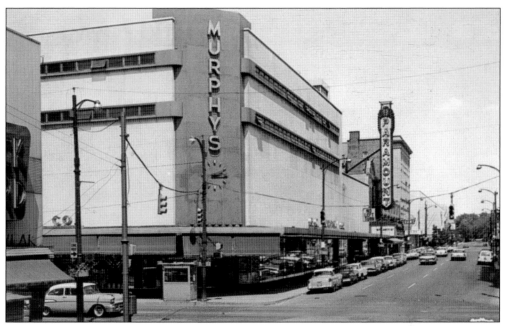

The Paramount Theatre was built in 1931 on the site of the original Fort Wayne High School, which had been replaced with the construction of the new Central High School at Lewis and Barr Streets in 1903. At 119 East Wayne Street, it was just east of the G.C. Murphy's store and reportedly surpassed the Embassy in opulence. The movie theater closed in 1961 and was razed in 1962.

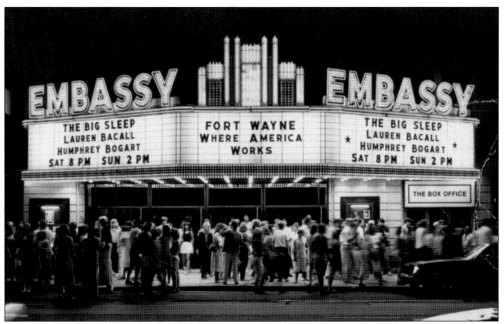

In addition to the large, revered theaters like the Embassy (captured in this 1987 postcard by John Hornberger), the city enjoyed numerous neighborhood theaters. Many were named for the streets on which they were located, including Maumee, Wayne, Wells, State, Broadway, Capitol, Eastern, Rialto, Indiana, and others. (Courtesy of John Hornberger.)

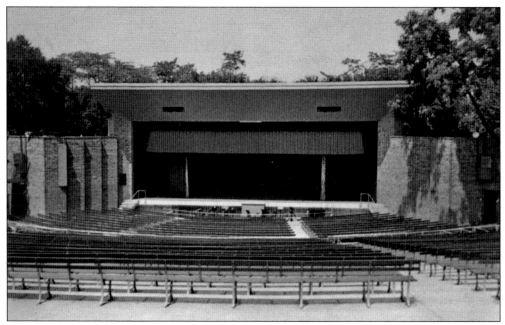

The open-air Foellinger Outdoor Theatre was dedicated in 1949 as the News–Sentinel Outdoor Theatre. It was a gift to the city from Helene R. Foellinger in memory of her father, Oscar Foellinger, longtime publisher of the *News-Sentinel*. The stage buildings were damaged by fire in 1972, but the theater was rebuilt and improved, including the addition of an expansive, freestanding roof in 1976.

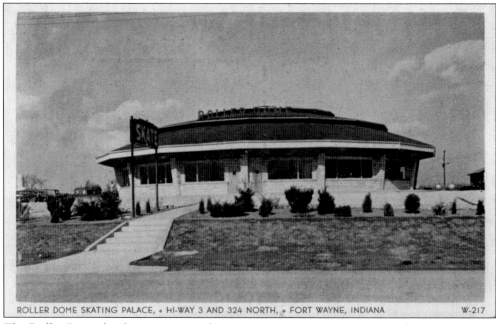

ROLLER DOME SKATING PALACE, • HI-WAY 3 AND 324 NORTH, • FORT WAYNE, INDIANA W-217

The Roller Dome has been an iconic destination since its opening in 1950 by Jim and Marg Wall. It has had children of all ages cheerfully doing the Hokey Pokey on skates for over 60 years, and it sits adjacent to another 1950s institution, Don Hall's Hollywood Drive-in, at Lima Road and Coliseum Boulevard.

Two

HOOSIER HOSPITALITY

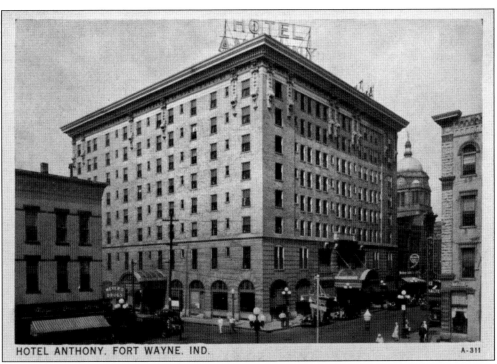

HOTEL ANTHONY, FORT WAYNE, IND. A-311

Completed in 1908 at the northeast corner of Berry and Harrison Streets, the Anthony Hotel, designed by local architect Charles Weatherhogg, would be a leading meeting place for over 65 years. Later renamed the Van Orman, the nine-story, 263-room hotel would be imploded in January 1974 to make room for a parking lot for the newly constructed Fort Wayne National Bank next door. The hotel, which required three years to build, came down in nine seconds.

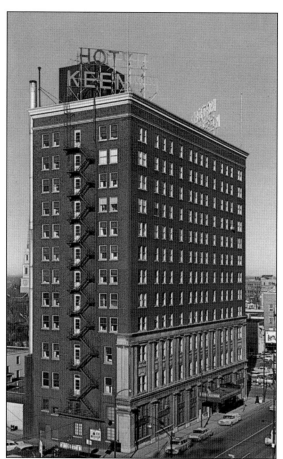

H.J. Keenan had been the manager for the Anthony Hotel when it opened in 1908. In 1923, he opened a competing hotel—the Keenan—at the southwest corner of Harrison and Washington Streets. In 1924, the city's first radio station, WHBJ (later WGL) broadcast from the hotel's mezzanine. The 13-story structure was imploded in October 1974, and the site is now home to a parking lot.

Operated by Irish manager Thomas J. O'Dowd, the 34-room, flag-draped Rich Hotel opened in 1885 and was located at 1226 South Calhoun at Lewis Street. The Rich, like dozens of small hotels in the downtown area (including the Kindler, Cortland, Weber, Lake Shore, Home, Lincoln, Palace, Victoria, and others), is no longer in existence.

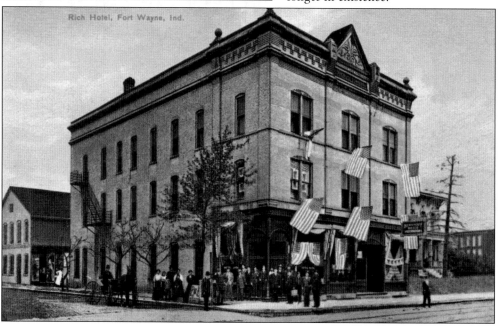

Rich Hotel, Fort Wayne, Ind.

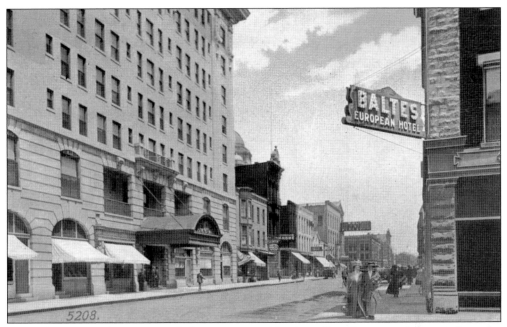

Opened in 1908, the 60-room Baltes European Hotel sat directly across the street from the imposing Anthony Hotel. Located at the southeast corner of Berry and Harrison Streets, it is remembered for the famous Berghoff Gardens Restaurant, opened in 1932, attached to the back (south end) of the building and facing Harrison Street. This site is now a parking lot.

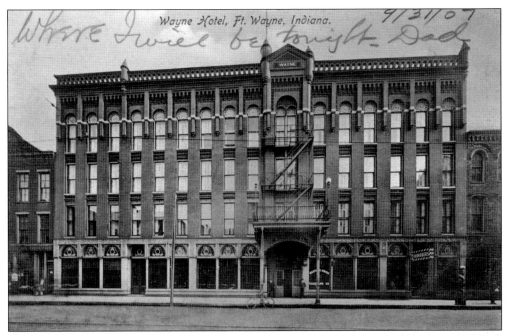

The Wayne Hotel, opened in 1887 and sitting in the middle of the Landing block on the south side of Columbia Street, would later be called the Jones Hotel. Still later, in 1966, it would be re-branded as the Rosemarie. Destroyed by a horrific fire in 1975, it was the city's first 100-room hotel. Over the years, Presidents Harrison, Garfield, and Hayes stayed there.

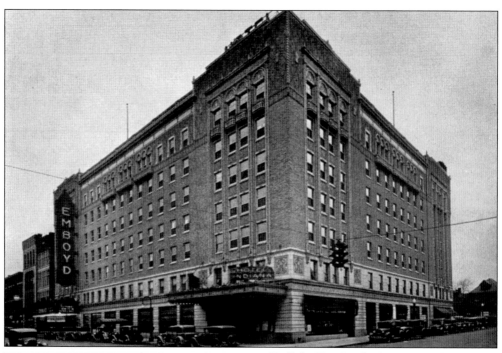

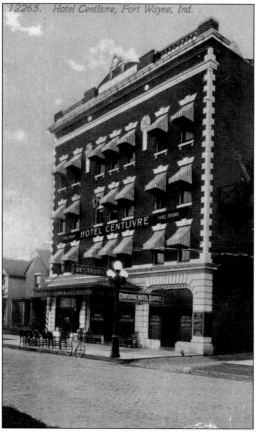

12265. Hotel Centlivre, Fort Wayne, Ind.

Built by Fox Realty in conjunction with the Emboyd (Embassy) Theatre, the Indiana Hotel featured nearly 250 guestrooms and had its grand opening in the spring of 1928. The hotel's close proximity to the Baker Street and Wabash railroad stations made it a popular overnighting spot. The hotel closed in 1971, and in 1995, part of the interior was removed to increase the stage size for the Embassy Theatre.

Designed by architect John Riedel and built in 1909 by a company headed by brewer Charles F. Centlivre, the Centlivre Hotel was located at 118 Baker Street nearly across from the Baker Street railroad station and only a block from the Wabash station. It then became the Milner Hotel, which advertised rates of $1 per day or $4 per week. Renamed the Reid Hotel, it was razed in 1963.

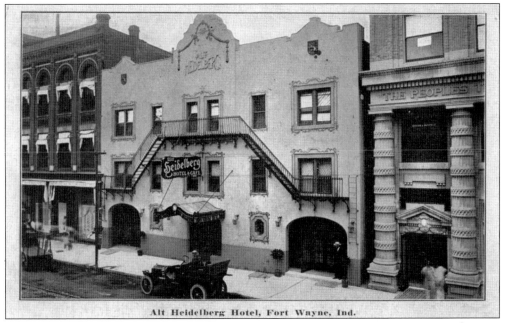

Once known as the Grand Central Hotel, this structure was later enlarged and, in 1917, became the Alt Heidelberg Hotel. Its location was in the block of South Calhoun Street between Wayne and Washington Streets and just north of the Peoples Trust Bank. The hotel would later become the site of the Grand Leader department store, which, after its 1927 fire, was rebuilt and renamed Stillman's. One Summit Square's plaza now occupies this site.

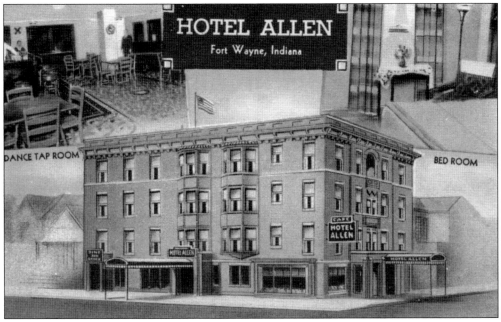

The 60-room Hotel Allen from the 1920s sat at the southwest corner of Washington and Webster Streets. It was removed for a parking lot as part of the expansion of the main Allen County Public Library, which was completed in 2007. At one time, the Allen billed itself as "Fort Wayne's Finest Small Hotel;" in later years, it became a rooming house.

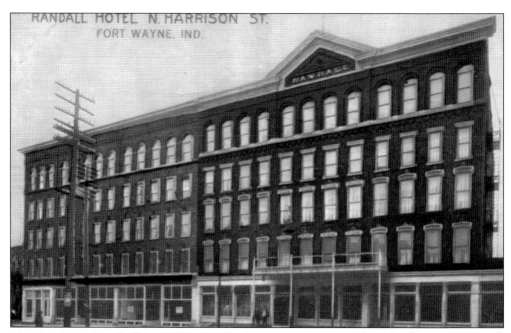

The Grand Hotel was built in 1871 just north of the Seavy/Wayne Hardware building, at 606 South Harrison. It enjoyed such guests as Buffalo Bill's Wild West Show. The Grand was subsequently purchased by Perry Randall in 1889 and renamed the Randall Hotel; it was eventually razed in 1963. This site is now the parking lot at the western foot of Columbia Street.

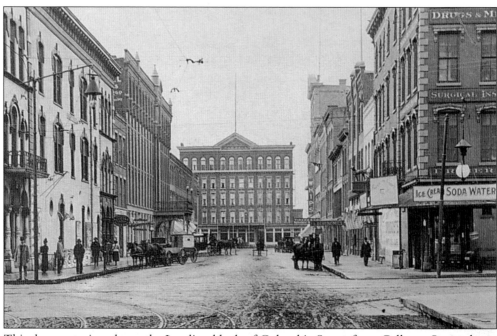

This due-west view down the Landing block of Columbia Street from Calhoun Street shows the Randall Hotel at its Harrison Street foot. Additionally, the Wayne/Jones/Rosemarie Hotel is pictured to the left at 199 West Columbia, in the center of the block.

One of the first "new" downtown hotels was the Sheraton, built at 300 East Washington Boulevard at the southwest corner of Washington and Lafayette Streets in 1969. Later, from 1980 until 2007, it would be re-branded as the Holiday Inn–Downtown. In 2011, it reopened as the Lamplite Inn of Fort Wayne, a senior-living community.

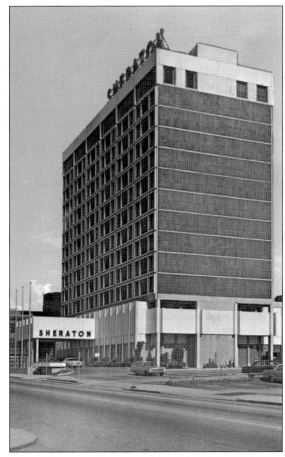

This 1950s TraveLodge Motel sat on the northeast corner of 1201 South Harrison Street at Lewis Street, directly behind the Indiana Hotel. After it was razed, the site became part of the property utilized by the Foellinger-Freimann Botanical Conservatory, opened in 1983.

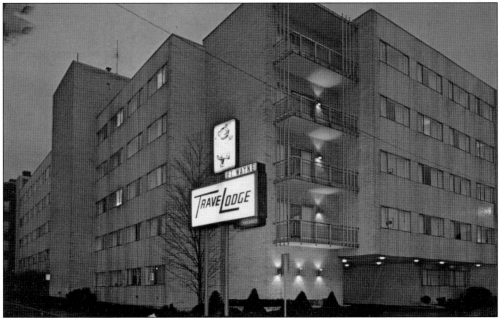

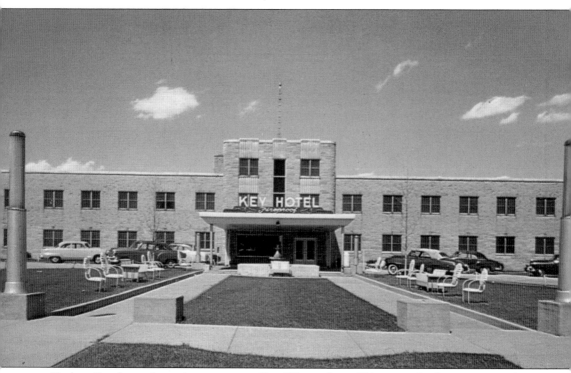

Goshen Road was the main entrance to Fort Wayne from Chicago and other points northwest prior to the construction of the "Circumurban" (Coliseum Boulevard), which began in the late 1940s. As the population fled to the suburbs, so too did the hotels begin to leave downtown. Pictured is the 1950s 125-room Key Motor Hotel, which later was renamed the Key Largo Inn, adjacent to Club Olympia. Club Olympia had opened in 1963, and its pool remained in operation until 2009. Also along this stretch were the Knotty Pine and West-Acres motels. With urbanization, other hotels sprang up on or near the Circumurban bypass, including the Gerberhaus, Van Orman–Northcrest (which would later be renamed the Northcrest Motor Inn), Four Winds, and Johnny Appleseed Motel. When Interstate 69 was built in the 1960s, hotels would begin making a further leap from the bypass to building along Washington Center Road and the interstate exits at Goshen, Lima, and Coldwater Roads. These included the Imperial House (now Hall's Guesthouse), the Marriott (which featured the Win Schuler's restaurant), Hospitality Inn, and Holiday Inn Northwest.

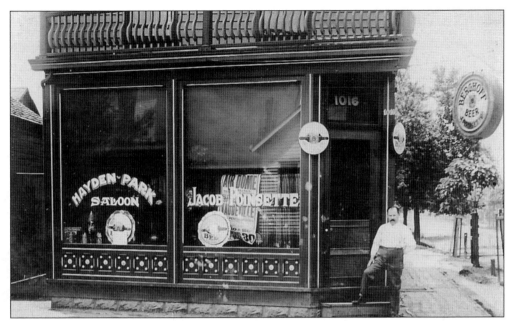

In 1910, at a time when the population of Fort Wayne was only 63,000 people, there were 197 saloons, an amazing 39 of which were located on Calhoun Street alone. Most saloons, or as they were sometimes euphemistically called, "sample rooms," featured either Berghoff or Centlivre beers. As can be seen here, the Hayden Park Saloon on Maumee Avenue was a Berghoff location. (Courtesy of Gene Branning.)

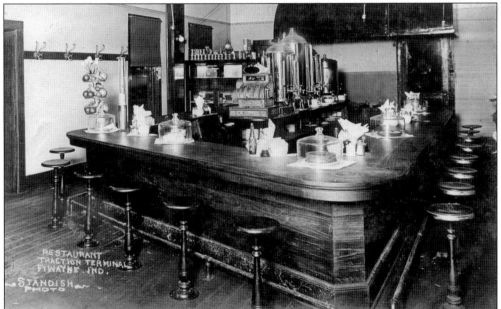

Located in the 300 block of West Main Street inside the interurban terminal, the Traction Terminal restaurant was ready to serve gallons of coffee and sweets in this c. 1920 postcard image. The passenger interurban system was part of a network that connected hundreds of communities and encompassed 2,000 miles of track in Indiana. The first regular interurban service from Fort Wayne began in 1901, and the last ran in 1941. (Courtesy of Jane Lyle.)

Few local mid-century restaurants evoke more fine-dining memories than the Berghoff Gardens. Located on the east side of Harrison Street between Berry and Wayne Streets, it abutted the back of the Baltes Hotel. Opened in 1932, the upscale restaurant closed in 1957, and in the early 1960s it served for a time as a "teen club." The building was razed shortly after a suspected arson fire destroyed part of it in 1964.

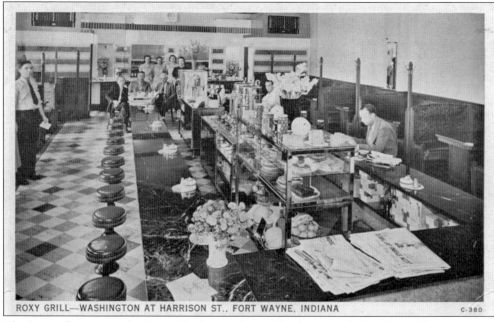

The layout featured at the Roxy Grill, complete with glass cases brimming with sweets, was typical for the 1930s and 1940s. The Roxy, "where food excels," was located at Harrison and Washington Streets.

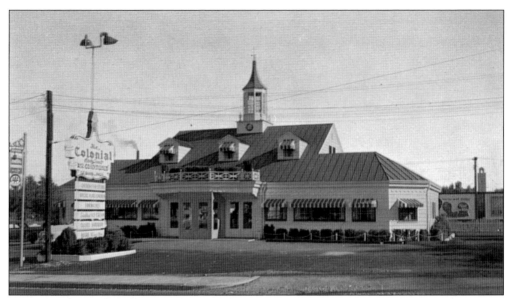

Frank Gardner opened the popular Gardner's Drive-In on West Jefferson at Webster in 1935 and sold it in 1955. He then started the Char-King chain in 1957. After opening five locations, he sold it to Azar Inc. in 1971, and the new owners renamed it Charky's. The Colonial Restaurant pictured above, located at the corner of Bueter Road and New Haven Avenue, was opened by Gardner in 1941 and sold in 1946. It would finally close in 1965.

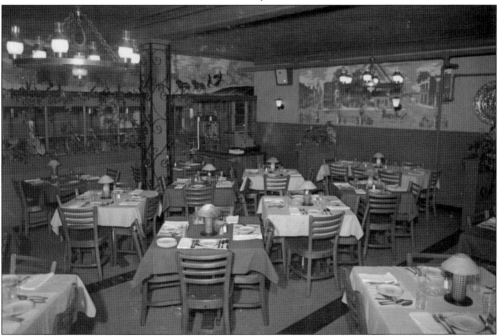

For many years, Bob & Bud's Coach Room at 2650 Bueter Road was the beneficiary of the swelling east end industries that included International Harvester, Zollner Piston, Magnavox, ITT Aerospace, Capehart-Farnsworth, Fort Wayne Truck Engineering, Phelps-Dodge, and other companies that found a home in the Pontiac Street/Bueter Road (now Coliseum Boulevard South) corridor.

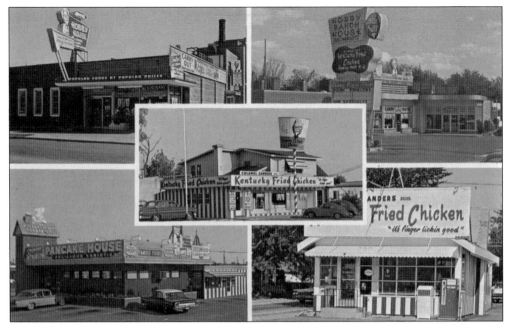

Among Fort Wayne's fondly remembered restaurants are Phil Clauss's Hobby House restaurants and the city's first Kentucky Fried Chicken. Pictured clockwise from the top left are Hobby Ranch House at 230 East Wayne Street, Hobby House Anthony at Crescent Avenue, Colonel Sanders on South Lafayette, Ranch Pancake House on Lincoln Highway East New Haven, and in the center, the Bluffton Road Kentucky Fried Chicken.

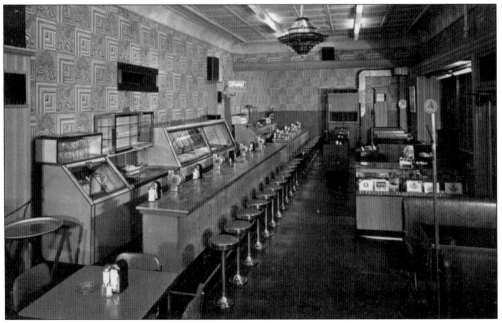

Machon's, a c. 1950 restaurant, opened at the corner of Berry and Harrison Streets with its more upscale Marine Cocktail Lounge next door. Being across the intersection from both the Anthony and Baltes Hotels was likely good for business.

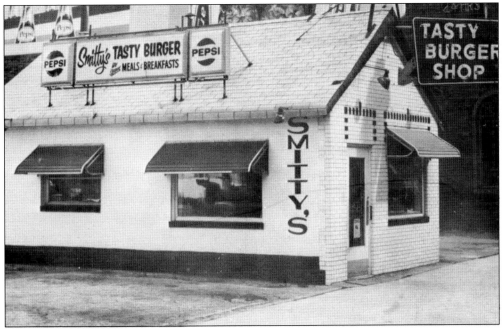

Now this was a burger joint. Smitty's Tasty Burger Shop sat at 128 West Jefferson Boulevard next to the Jefferson Theatre, where the Hilton Hotel now sits, right across from today's Foelllinger-Freimann Botanical Conservatory.

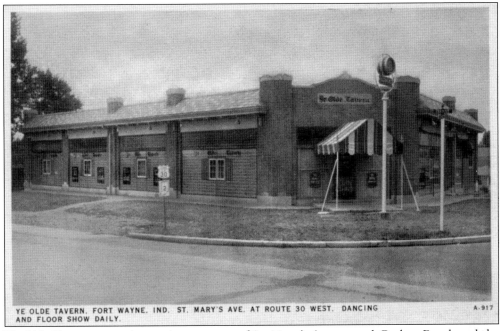

YE OLDE TAVERN. FORT WAYNE. IND. ST. MARY'S AVE. AT ROUTE 30 WEST. DANCING AND FLOOR SHOW DAILY. A-917

Ye Olde Tavern sat at the southeast corner of St. Mary's Avenue and Goshen Road, and the building is still there. The interior pictures of this tavern show a large dance floor. Until a few years ago, the popular Five Points Tavern stood across the street and south a few doors where Goshen Road and Sherman Street intersect with Lillian Avenue.

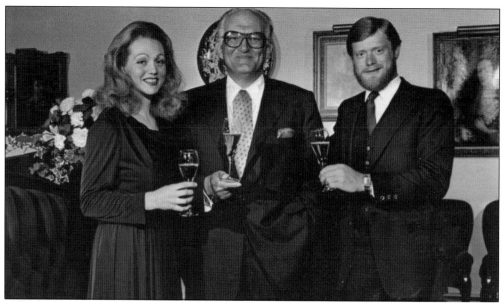

In the late 1950s, John Spillson opened a chicken and rib carryout, which was later converted to a pizza carryout on South Calhoun Street at Woodland Avenue. In the early 1960s, he remodeled the building into a French restaurant, reopening as Café Johnell's. Upscale, with a four-star Mobil Guide rating, Café Johnell was felt by many to be the pinnacle of local dining. John (center) is pictured with daughter Nike and son Jon.

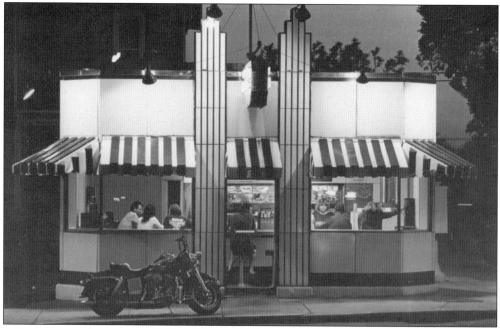

At Powers Hamburgers, eating the onion-embedded sliders has been a rite of passage in Fort Wayne since 1940, and they still serve or sack them today at the southwest corner of Harrison and Brackenridge. In the same category, but not pictured, is the perennial favorite Coney Island Wiener Stand (whose "buns are steamed") that opened at 131 West Main Street in 1914. (Courtesy of the photographer, John Hornberger.)

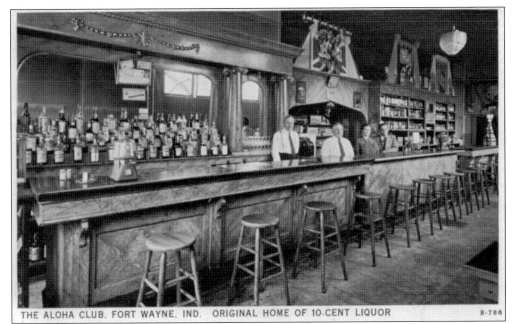

THE ALOHA CLUB. FORT WAYNE. IND. ORIGINAL HOME OF 10-CENT LIQUOR B-788

The Aloha Club (also called the Aloha Gardens), just south of Suttenfield at 2520 South Calhoun, claimed that on January 1, 1935, they served the first 10¢ glass of liquor since repeal of the 18th Amendment; they also asserted that they were also the originators of French-fried hamburgers.

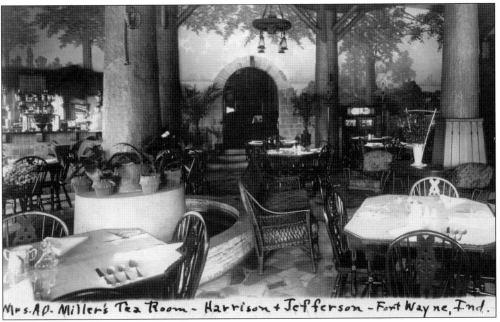

Mrs. A.P. Miller's Tea Room - Harrison + Jefferson - Fort Wayne, Ind.

Miller's Tea Room sat at the southwest corner of Harrison Street and Jefferson Boulevard, now the site of the Marriott Courtyard hotel. Over the years, Luella Miller's establishment was also called Miller's English Tea Room, English Terrace Restaurant, and in the 1950s, the Terrace Room Restaurant and Cocktail Lounge. The second floor housed the Colonial Hotel for a time.

In 1946, Don Hall opened his first of many successful restaurants—the Hall's Drive-In—adjacent to the St. Mary's River on Bluffton Road. Today, the local family-owned-and-operated chain continues to thrive and features a dozen locations, including Don Hall's Gas House at the corner of Lafayette and Superior Streets, whose interior is pictured here. Fort Wayne has long been known as a restaurant city. A few of the notable examples that are now gone include Azar's Moonraker and Wharf as well as the various Big Boy locations around town, Gouloff's Paramount Grill, Cardone's, Bob Inn, Peter's, Chen's, the Carriage Inn, the Ground Round, Holly's Landing, Gardner's Drive-in, Dawson's Root Beer, the Golden Dragon, A&W Root Beer, Bill Knapp's, Carousel, the Colonial Restaurant, Wilson's Chicken Shack, Helmsing's Lighthouse, the Elegant Farmer, various Char-Kings locations, Heritage House, Papa Suzetti's, Ted & Tom's, Trolley Bar, Blue Mountain Café, the Pickle, Tiny Tim's Diner, Raver's Victory Club, Glenbrook's L.S. Ayres Tea Room, Danner's and MCL Cafeteria, and many others that are dearly missed.

Three

WE ARE HERE TO HELP

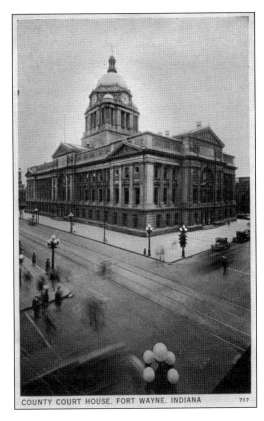

COUNTY COURT HOUSE, FORT WAYNE, INDIANA 717

A more beautiful courthouse would have been hard to find when Fort Wayne's was dedicated on September 23, 1902. Built and furnished for just over $817,000, it took five years to construct. The Beaux Arts building, designed by Brentwood S. Tolan, features Blue Bedford limestone, Vermont granite, and white Italian marble. At 270 feet long and 134 feet wide, it stands 225 feet tall from the sidewalk to the top of the statue.

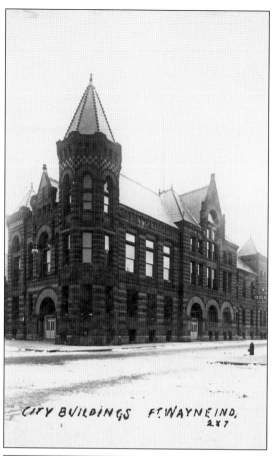

CITY BUILDINGS FT. WAYNE IND.
2 87

Located at the southeast corner of West Berry and Barr Streets, the one-time city hall has been restored and is now home to the History Center. Completed in 1893, it was built on land that had been donated by Samuel Hanna. Designed by well-known Fort Wayne architects J.F. Wing and M.S. Mahurin, the Richardsonian Romanesque building is constructed of sandstone. (Courtesy of Jeanette Reitz.)

The Barr Street Market was founded shortly after land for it was donated in 1837. In 1855, a two-story brick market building was constructed; it would later be removed when the new city hall was built in the 1890s. This open-air, two-block-long version opened in 1910. Operating six days a week during the season, this once bustling market with 120 stands was razed between 1957 and 1958.

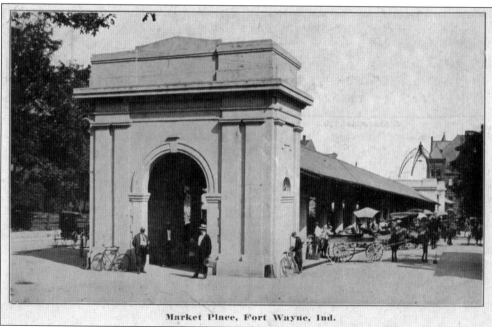

Market Place, Fort Wayne, Ind.

Completed in 1889, the imposing sandstone federal building and post office sat at the southeast corner of Berry and Clinton Streets. Local mail delivery had started in 1873, prior to which a trip to the post office was required to collect the mail. At the turn of the century, mail was delivered in the downtown district four times per day. This building was razed in 1938. (Courtesy of Jeanette Reitz.)

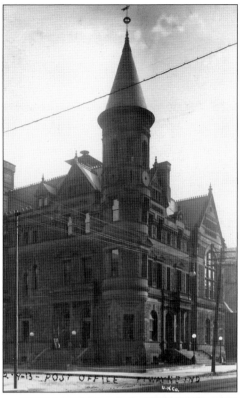

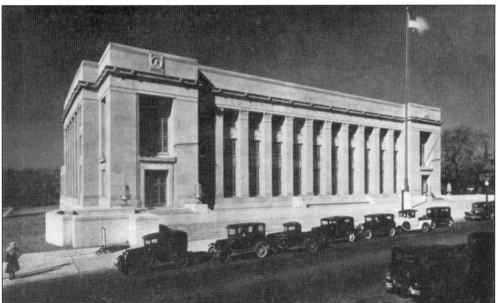

Facing the home offices of Lincoln National Life Insurance, the federal courthouse and post office building was completed in 1932 on South Harrison Street. While the first floor and basement were dedicated to the post office, the second and third floors housed the US District Court, Federal Bureau of Investigation, Internal Revenue Service, and military recruiting offices. It is now the E. Ross Adair Federal Building and United States Courthouse.

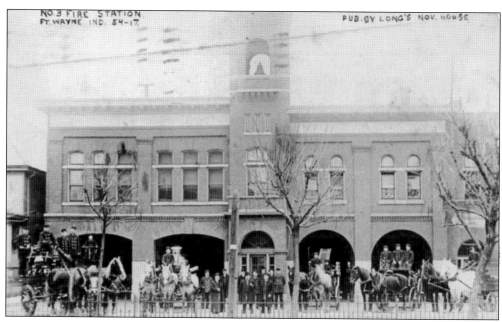

Engine House No. 3, built in 1893, was erected at 226 West Washington Boulevard. In 1907, it was doubled in size and the bell tower was added, making it the city's largest firehouse. Adjacent to the new downtown library, the renovated and reconstructed firehouse is now home to the Fort Wayne Firefighters Museum and features exhibits, displays, and period firefighting equipment illustrating the department's early history. (Courtesy of Todd Baron.)

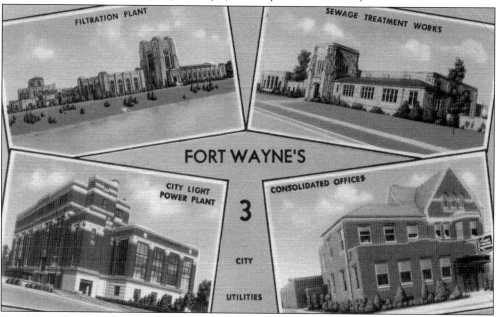

Fort Wayne's utilities were something to be proud of on this 1940s postcard. This included the city light power plant on North Clinton, completed in 1908, the filtration plant at the three rivers, completed in 1933, and construction of the sewage treatment works on Dwenger Avenue, which had begun in 1939. The consolidated offices for city utilities were on East Berry next to city hall.

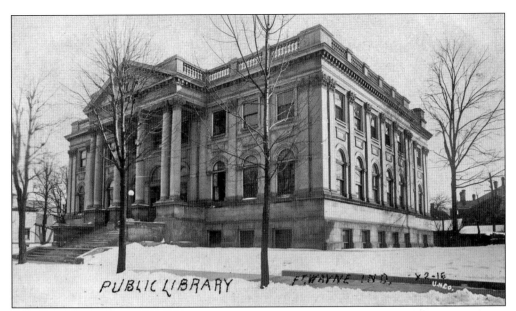

PUBLIC LIBRARY FT.WAYNE IND.

The downtown library at West Wayne and Webster Streets was built in 1904 at a cost of $110,000 (of which $90,000 was donated by industrialist Andrew Carnegie). This building was razed in the 1960s for the construction of a new library, which opened in 1968. Now, a larger, state-of-the-art library, completed in 2007, sits at this location. Additionally, the Allen County Public Library now features 13 branches.

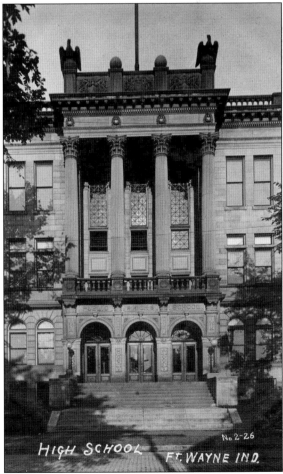

HIGH SCHOOL FT.WAYNE IND.

Fort Wayne's first high school sat on the north side of the middle of the 100 block of East Wayne Street. In 1903, it was replaced when the new Central High School (pictured) opened at Barr and Douglas Streets. The home to the Tigers, Central closed in 1971 and was converted into a vocational training school, renamed the Bill C. Anthis Career Center.

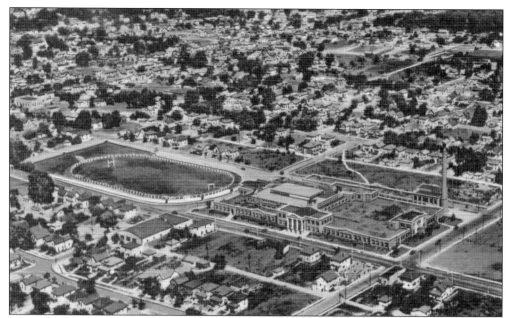

South Side High School, home of the Archers, was opened on South Calhoun Street in 1922 to relieve pressure on the overcrowded Central High School. A $39 million renovation and expansion was completed in 1996, with the school now featuring the city's only Olympic-sized natatorium. Other city high school openings followed, including Elmhurst in 1929, Snider in 1966, Wayne in 1971, and Northrop in 1972.

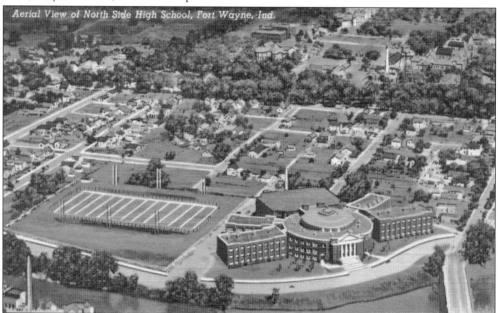

North Side High School, home to the Redskins, opened on the banks of the St. Joseph River in 1927. Designed by Charles Weatherhogg, the domed structure featured an indoor swimming pool, gymnasium, and what was arguably Fort Wayne Community Schools' most beautiful auditorium. North Side underwent an extensive $49 million renovation and expansion beginning in 2002. At over 400,000 square feet, it is now the system's largest high school in area.

With its beginning as the Brothers School in 1884, Central Catholic High School would officially open in 1909 as an all-boys school in the impressive Library Hall building at Calhoun and Douglas Streets (pictured). Girls attended St. Augustine's High School at the north end of the square, at the corner of Calhoun and Washington Streets. (Courtesy of Jeanette Reitz.)

Leaving Cathedral Square in 1938, the new Central Catholic High School, designed by Alvin M. Strauss, was erected at 130 East Lewis Street. Dedicated by Bishop Noll in 1939, it became a coeducational high school. When it closed in the spring of 1972, students transferred to the two newer Catholic high schools—Bishop Luers High School (the Knights) and Bishop Dwenger High School (the Saints).

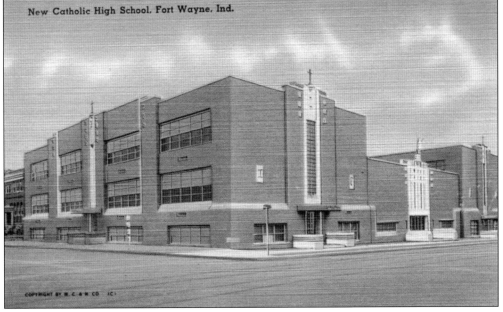

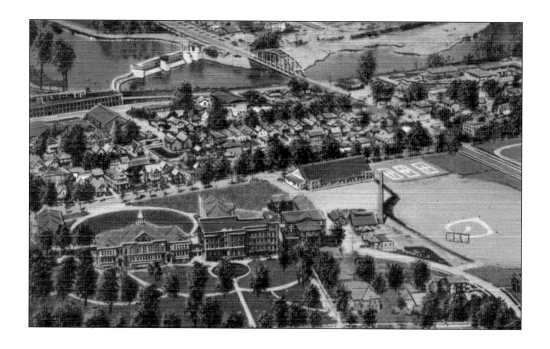

Concordia Junior College (above) was located on the site of the current Indiana Tech Campus at 1600 East Washington Street at South Anthony Boulevard. An expansive property with numerous buildings, it was founded in 1861. The college was closed at this location in 1957 and moved to the newly constructed Concordia Senior College, designed by Eero Saarinen and located on North Clinton Street. The college is now known as Concordia Theological Seminary.

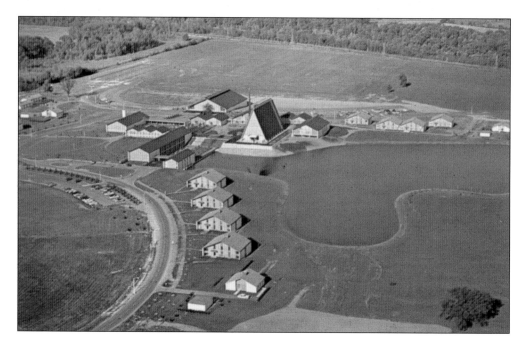

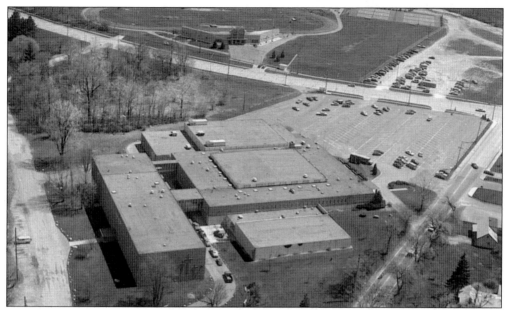

Concordia High School (home of the Cadets) opened on the grounds of the old Concordia Junior College on East Washington Street and South Anthony Boulevard in 1935. The school was moved to this newly erected North Anthony Boulevard facility in 1964. Built on ground purchased in 1958, the school gained the stadium Fred Zollner had built for his fastball Zollner Pistons team and has continued to grow.

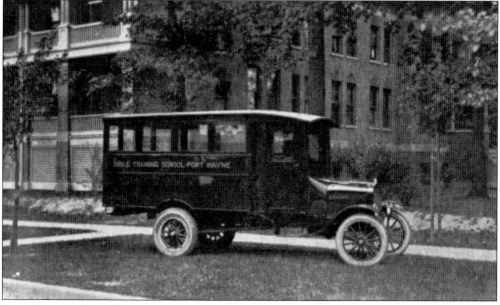

Fort Wayne Bible College was opened by the Missionary Church Association in 1905 on East Rudisill Boulevard with the completion of Schultz Hall. The school had several names over the years, including Fort Wayne Bible Training School, Summit Christian, and Taylor University. With the construction of additional buildings, the campus spread to both sides of Rudisill Boulevard. Its final commencement was in 2009 before the school moved to the Taylor University campus in Upland, Indiana.

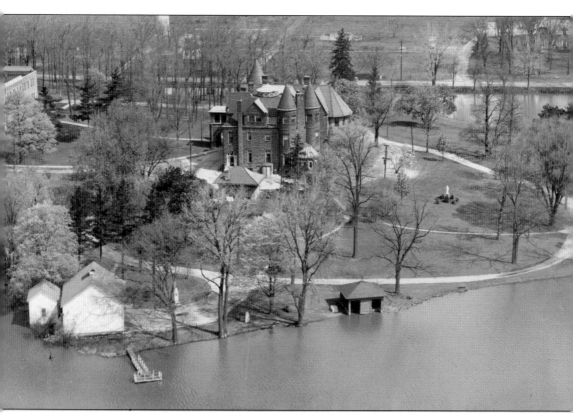

St. Francis College was founded in 1840 in Lafayette, Indiana, and moved to the palatial John H. Bass mansion, Brookside, on Bass Road in 1944. In 1947, Trinity Hall was completed, and in 1957 the first male students were admitted. Since then, the former Brookside grounds have continued to fill with modern buildings and facilities to expand the educational opportunities, and in 1998, the college's name was changed to the University of Saint Francis. The mansion was completed by John H. Bass in 1903 after his summer cottage, which had previously stood at this location, completely burned in 1902. The Romanesque masterpiece, designed by local architects Wing and Mahurin, sat next to a man-made lake on a 300-acre animal-filled setting, while Bass's primary home at that time was a large brick house at Fairfield Avenue and Berry Street. Extensive restoration began at the Bass mansion in 2009, funded in part by a grant provided by the National Park Service.

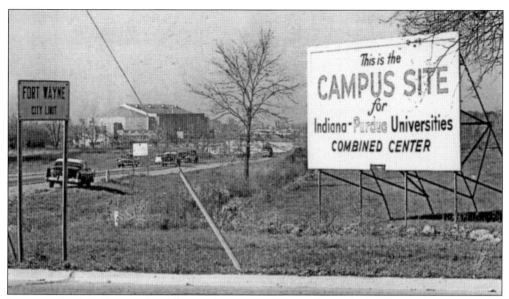

For years, both Indiana and Purdue Universities maintained separate extensions in Fort Wayne. Indiana University established an extension in 1917, and Purdue in 1941. In 1957, it was recommended by the schools' trustees that the universities join in building a common facility, and thus the former Fort Wayne State Hospital farmland on Coliseum Boulevard was later purchased. Completed in 1952, the Allen County War Memorial Coliseum is visible in the background of this image.

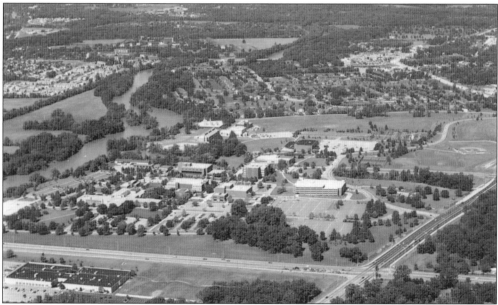

Indiana University–Purdue University Fort Wayne (IPFW) opened in 1964 with all functions taking place in the new Kettler Hall on the US 30 Bypass campus property. Today, the Mastodons enjoy an extensive campus offering 200 academic options on 682 acres with 40 buildings and structures, including on-site student housing. In the late 1970s, the affiliated Ivy Tech Community College built a large facility across the bypass from IPFW, offering over 30 associate degree programs.

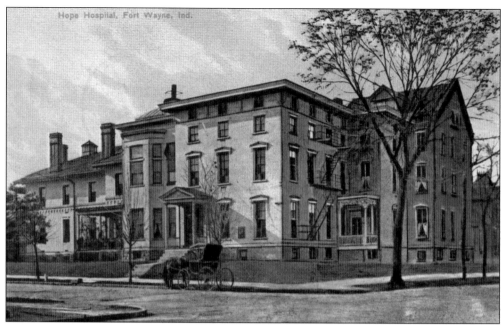

Fort Wayne City Hospital was first located on West Main Street for a very short time in 1878 before moving to the corner of Hanna and Lewis Streets for five years. Its next location, pictured here, was at the southwest corner of Washington and Barr Streets in the old Oliver Hanna homestead in 1883. It was renamed Hope Hospital in 1891.

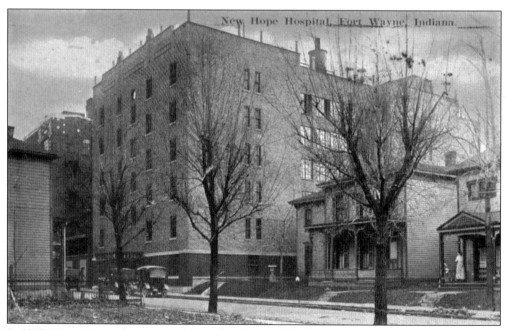

In 1917, Hope Hospital was moved from the Barr and Washington Streets location to the newly constructed Ways Sanitarium on West Lewis Street near Harrison Street, where it would stay until 1953. During that time, its name changed to Methodist Hospital. This site is now part of the Foellinger-Freimann Botanical Conservatory.

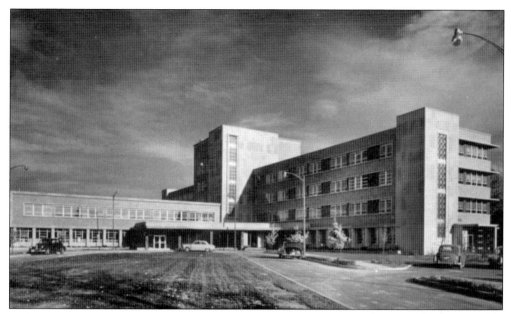

Parkview Memorial Hospital was the outgrowth of the prior Fort Wayne City Hospital, Hope Hospital, and Hope-Methodist Hospital. The new facility opened on Randallia Drive in 1953 with 242 beds. In 2012, it largely moved its Randallia facilities and headquarters to a new nine-story, 446-bed hospital named Parkview Regional Medical Center. Located off Dupont Road at Interstate 69, it now has over 7,000 employees.

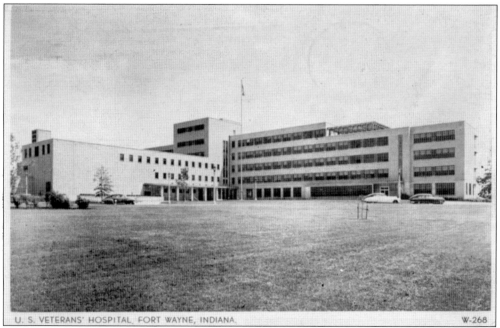

U. S. VETERANS' HOSPITAL, FORT WAYNE, INDIANA. W-268

The local Veterans Hospital at Randallia Drive and Lake Avenue was designed by local architect A.M. Strauss and opened its 200-bed, five-story facility in 1949. Combined with the Marion, Indiana, facility in 1995, it offers a wide range of health services for veterans under the name VA Northern Indiana Health Care System.

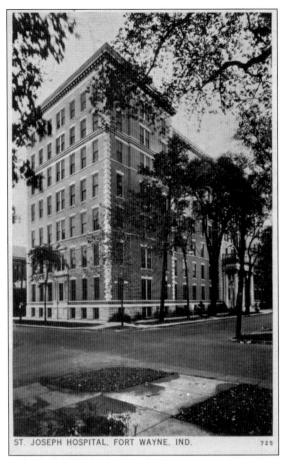

ST. JOSEPH HOSPITAL, FORT WAYNE, IND. 725

St. Joseph Hospital was born out of the 1868 purchase of the 65-room Rockhill House Hotel at Broadway and Main Streets. Operated by the Poor Handmaids of Jesus Christ, it opened in 1869 and was the first hospital in the city; it was also the first to operate a nursing school in Fort Wayne. Over the years, there have been many additions and changes to the point that the original hotel building no longer exists. Now part of the Lutheran Health Network, St. Joe offers 191 beds at its 700 Broadway location, has over 1,000 employees, and is well known for its regional burn center.

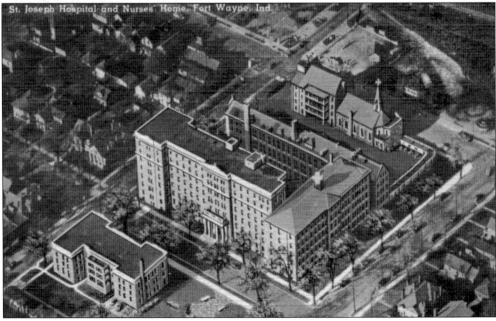

St. Joseph Hospital and Nurses' Home, Fort Wayne, Ind.

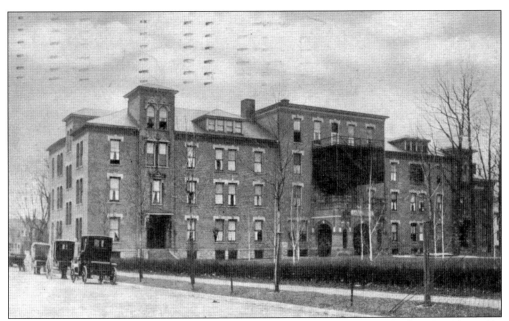

Founded by the Evangelical Lutheran Hospital Association, Lutheran Hospital opened on South Fairfield Avenue on Thanksgiving Day 1904. Opening originally in the substantial brick home of the former judge Lindley M. Ninde, the space allowed room for just 25 beds. The hospital expanded over the years and eventually opened a modern, new facility at that site in 1956. Continuing to expand, the hospital finally decided to move to a larger location at West Jefferson Boulevard and Interstate 69, with the first patients admitted there in 1992. More buildings followed at the new site, and an additional floor was added to the main hospital, which now offers 396 beds in total. The old hospital on Fairfield Avenue, pictured below, was razed in 2000 and was landscaped and opened as Lutheran Park and Gardens in 2006.

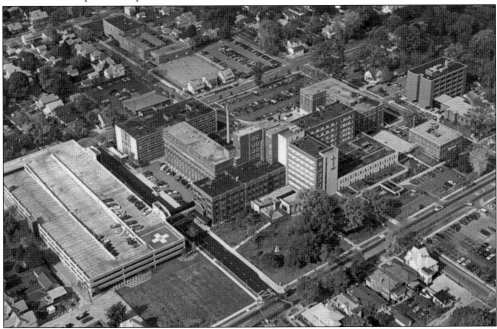

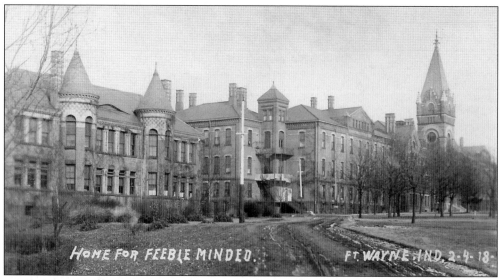

Opened in 1890, Indiana School for Feeble Minded Youth, later referred to as State School, was designed by local architects Wing and Mahurin. With numerous Gothic-style buildings and a tall iron fence, it was a dreary and imposing complex that encompassed over 16 square blocks. In the 1920s, over 1,500 patients were housed here. In 1982, the buildings were demolished and the site became Northside Park. (Courtesy of Todd Baron.)

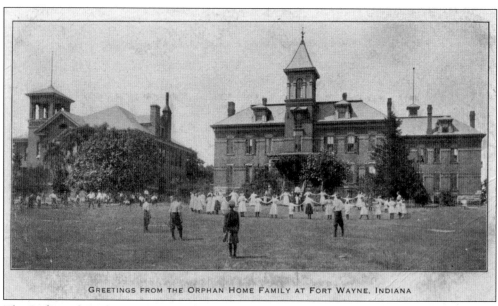

GREETINGS FROM THE ORPHAN HOME FAMILY AT FORT WAYNE, INDIANA

The Reformed Orphans Home was founded on the north side of Lake Avenue between Carew and Beacon Streets in 1883. Hundreds of orphans were cared for and placed in homes from here over the years, and in the 1950s, their mission was extended to provide a place for unwed mothers and emotionally troubled children. For many years known as the Fort Wayne Children's Home, today it is called Crossroad Child & Family Services.

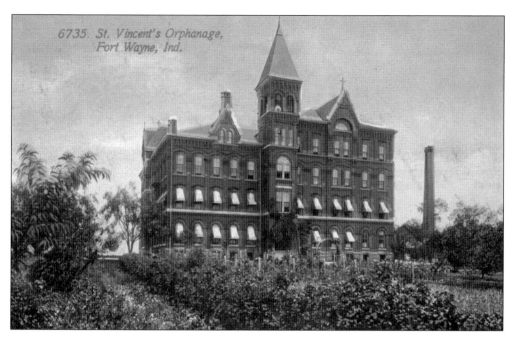

6735. St. Vincent's Orphanage, Fort Wayne, Ind.

Opening in 1887, with the cornerstone having been laid by Bishop Joseph Dwenger, St. Vincent's Orphanage—later renamed St. Vincent's Villa—was built at 2000 North Wells Street. Located on an expansive, treed property, the facility was for girls only until boys were also admitted in 1932, when the first of the new buildings was completed at the direction of Bishop John Noll. While the above 1887 main building would sadly be destroyed by fire in July 1950, a new campus designed by A.M. Strauss in the Mission/Spanish Colonial Revival style and started 18 years earlier would continue to grow. The orphanage closed and in 1977 was sold to the YWCA, which operated there until 2004. The Imagine Master Academy has utilized the campus since 2006.

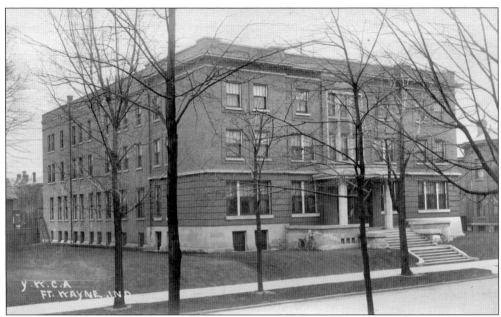

The local chapter of the YWCA, founded by Agnes Hamilton in 1894, erected the above building at 325 West Wayne Street in 1913. This three-story building contained a gymnasium, cafeteria, library, and, on the top two floors, a dormitory housing 40 women. The building was razed after the property was sold to the Allen County Public Library in 1977, and today the main library branch includes these grounds.

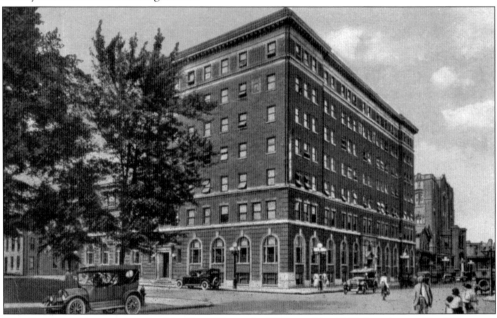

The first YMCA was organized in Fort Wayne in 1858, and in 1918 the pictured building was completed at the southwest corner of Barr and Washington Streets, the former location of Hope Hospital. This first YMCA has since become a parking lot for the new Central YMCA, which was built next door in 1985. The community now enjoys four YMCA locations, with a fifth under construction on St. Joe Center Road.

Four

THE ECONOMIC PULSE

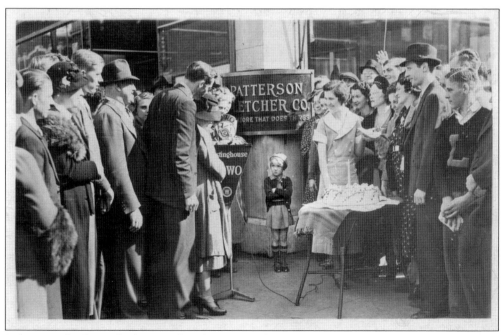

Patterson–Fletcher, which opened at the corner of West Wayne and Harrison Streets in 1917, is shown here during one of their WOWO *Man On The Street* promotions. Sam Fletcher, son of one of the founders, would go on to develop Northcrest Shopping Center and Interstate Industrial Park. Other men's clothiers besides the department stores included Meyers & McCarthy, Suedhoff & Butler, Golden's Men's Wear, Maier's, Rosenbaum's, Saul's, Brateman's, and Gladieux.

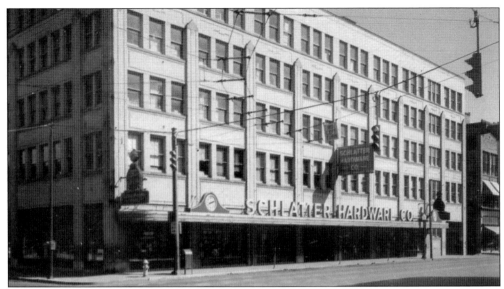

Founded in 1882, Schlatter Hardware Company, at the southeast corner of Clinton and Columbia Streets, was one of several large hardware wholesalers in Fort Wayne. When downtown redevelopment required their property in the 1960s, Schlatter moved to Merchandise Place near Interstate 69 in 1967. Local competitors included Mossman-Yarnelle, Wayne Hardware, Seavy Hardware, P&H Supply (now Wayne Pipe & Supply), Oren-VanArman Co., and National Mill Supply. (Courtesy of Jeanette Reitz.)

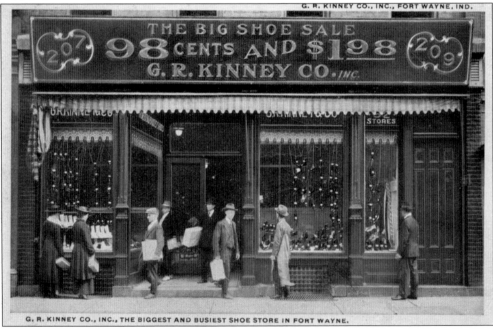

At 207 East Main Street, where Freimann Square is now, the prices for shoes at G.R. Kinney store were likely hard to beat. The national shoe store chain, founded in New York in 1894, had several locations in Fort Wayne over the years before the company dissolved in 1998. Some of the city's other mid-century shoe stores included Hanover Shoes, Hardy's, Toenges, Bakers, Klug, Fortriede, Edward's, and Green's.

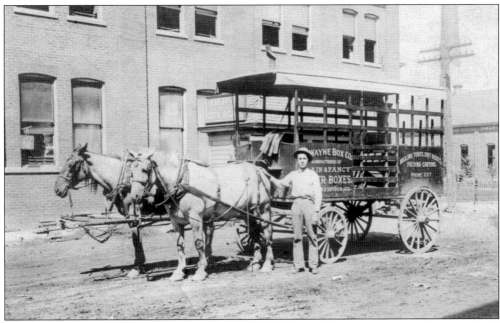

Founded in 1898, Wayne Box sat at the northwest corner of Superior (previously Water) and Harrison Streets. This enterprise would later be sold to Container Corporation of America in 1956, then to Jefferson-Smurfit in 1986, and finally to Altivity Packaging in 2006. Throughout the years, the plant produced various printed products—including postcards, gift cartons, calendars, and folding cartons—before it was finally shuttered in 2010.

Complete your

HORTON HOME LAUNDRY

With BOTH the Horton Washer AND the Horton Ironer, there is:

- New Freedom
- Less Work
- More Leisure Time
- A Finer, Cleaner Laundry
- Professionally Ironed.

Horton Manufacturing, founded in 1871, was located off West Main Street on Osage Street. The first home-use, self-contained washing machines, made of Louisiana cypress and branded under the names Spinner, Western Washer, and Round American, were produced here. Later changing to metal construction, as shown here, they made Horton electric washers as well as gas engine–powered "farm washers" and their line of Do-All electric irons.

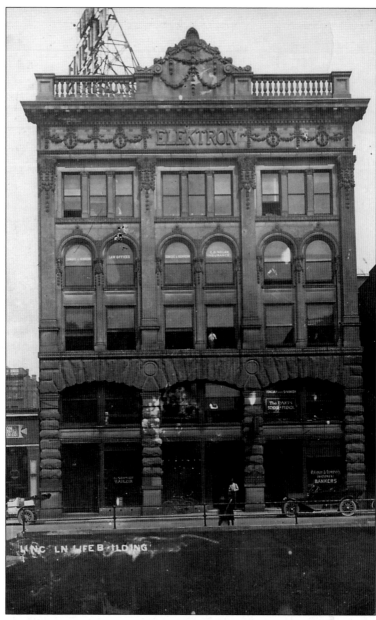

The Elektron Building, designed by Fort Wayne architects John Wing and Marshall Mahurin, was built at 215 East Berry in 1895. It reflects the interests of Ronald T. McDonald, the principle owner, who was also a founder of the Jenney Electric Company. From 1898 to 1902, the building served as the Allen County Courthouse while the new courthouse on Main Street was being built. In 1904, it housed the Allen County Public Library while the new Carnegie Library was under construction at West Wayne and Webster Streets. From 1912 to 1923, the period in which this postcard picture was taken, the building was owned by and used as the headquarters for the seven-year-old Lincoln National Life Insurance Company while its new home office was taking form on South Harrison Street at Douglas Street. At 120 years old, this structure has seen many temporary residents. However, since 1987, it has been the proud home of the law firm of Barrett & McNagny. (Courtesy of Craig Leonard.)

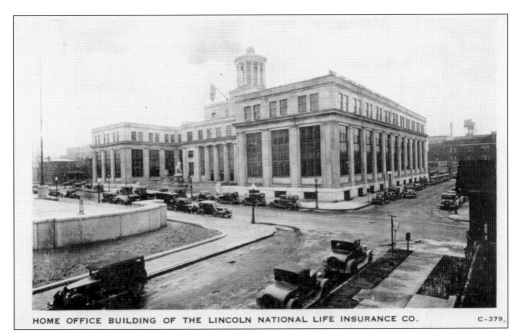

HOME OFFICE BUILDING OF THE LINCOLN NATIONAL LIFE INSURANCE CO. C-379

The new Lincoln National Life Insurance Company, completed in 1923, is pictured as it appeared in the early 1930s. Under early leaders Samuel Foster and Arthur Hall, Lincoln was to grow quickly from its 1905 beginnings. On the steps leading up to the entrance is the *Hoosier Youth* statue, which was sculpted by Paul Manship, cast in Belgium, and unveiled at a ceremony in 1932.

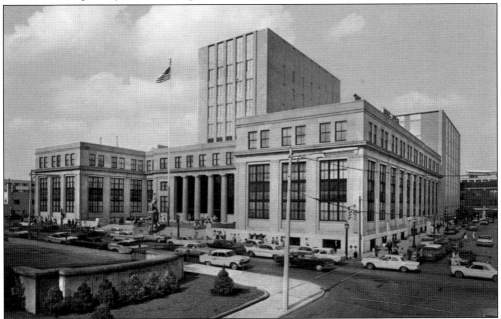

Pictured is the Lincoln headquarters after its 1960 expansion. Later, under the leadership of chief executive officer Ian Rolland, the former W&D's department store at Wayne and Clinton Streets was renovated in 1994 as the new Lincoln National headquarters. While Lincoln's footprint here in Fort Wayne has since changed, the city could not have hoped for a more generous and civic-minded philanthropic partner.

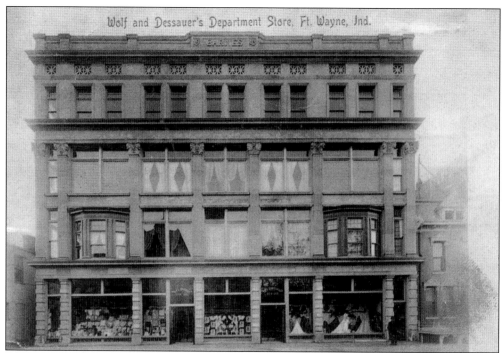

Wolf and Dessauer's Department Store, Ft. Wayne, Ind.

Sam Wolf & Myron Dessauer opened their first small, 12,000-square-foot store in 1896 on Calhoun Street. In 1908, they would move to this building, designed by architect Alfred Grindel, on West Wayne Street in the block bounded by Calhoun and Harrison Streets. Located on the south side of West Wayne, this site would later become the location for the new 12-story First National Bank in 1920.

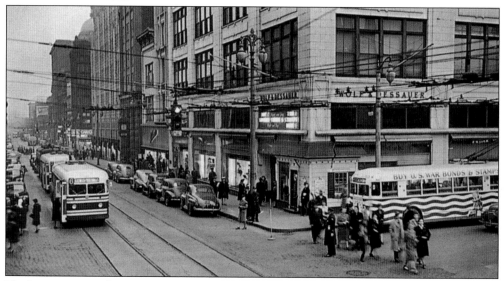

Having outgrown the West Wayne Street location, the store moved into this new, seven-story building at the northeast corner of Calhoun and Washington Streets in 1918. Founders Sam Wolf and Myron Dessauer then sold their interests in the company to the Latz family in 1920. An illuminated Santa and Christmas wreath were built in 1937 to adorn this building, which also featured the animated windows so many remember at Christmastime.

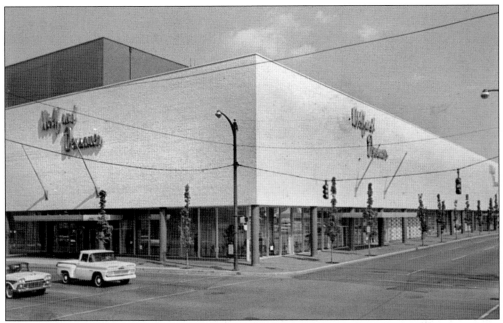

In 1959, the new Wolf & Dessauer store opened at the corner of Wayne and Clinton Streets, as shown here. The old building at Calhoun and Washington Streets was destroyed in a raging 10-hour fire in February 1962 and is now the site of One Summit Square. In later years, W&D's would be sold to City Stores and, in 1969, to L.S. Ayres.

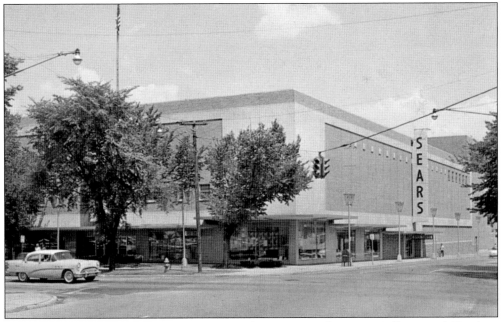

The Sears Roebuck store on the south side of Berry Street between Calhoun and Harrison Streets, across the alley from the First National Bank, was destroyed in a 1944 fire. The huge new store pictured here was opened in the fall of 1953 at the northwest corner of Rudisill Boulevard and South Clinton Street. In 1966, with the opening of Glenbrook Square, a second Sears was added to the city.

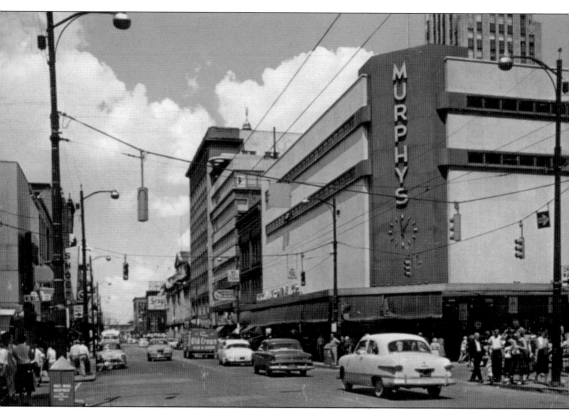

From 1890 until 1948, the dark brownstone Independent Order of Odd Fellows (IOOF) building sat at the northeast corner of Wayne and Calhoun Streets. With its razing, the new G.C. Murphy's store was constructed of limestone with red granite trim and opened in the fall of 1950. With 112,000 square feet of store space, it remained one of the city's favorite shopping destinations until closing in 1992. This site is now occupied by Wells Fargo Bank. While it was considered Fort Wayne's Murphy's (and the Fort Wayne location was reportedly one of its top-volume stores), it actually was part of a 500-store chain founded by George Clinton Murphy in 1906 in McKeesport, Pennsylvania. Calhoun Street at one time also featured five-and-dime stores W.F. Woolworth, W.T. Grant, S.S. Kresge, and Neisner's.

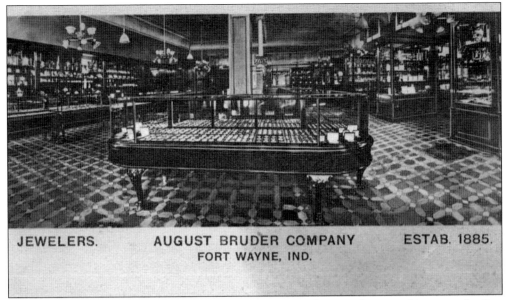

JEWELERS. AUGUST BRUDER COMPANY ESTAB. 1885.
FORT WAYNE, IND.

The August Bruder jewelry store was located at South Calhoun and Wayne Streets on the first floor of the IOOF building, later the location of Murphy's. This area was a prime location for many of the city's other leading jewelry stores over the years, including Cousins, Koerber, Carl Rose, Baber, Kay, and Springer.

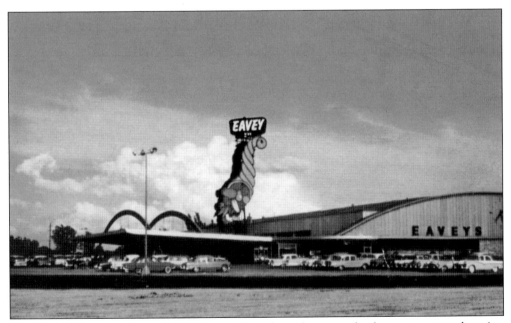

The Eavey's Supermarket at 5300 Decatur Road brought a completely new grocery shopping experience to Fort Wayne when it opened in July 1956 with the slogan "A place where shopping's fun." Featuring a 70-foot-tall cornucopia sign, six-foot-wide grocery aisles, and 14 checkout lanes, its gondola-filled, football field–sized interior was a sight to behold.

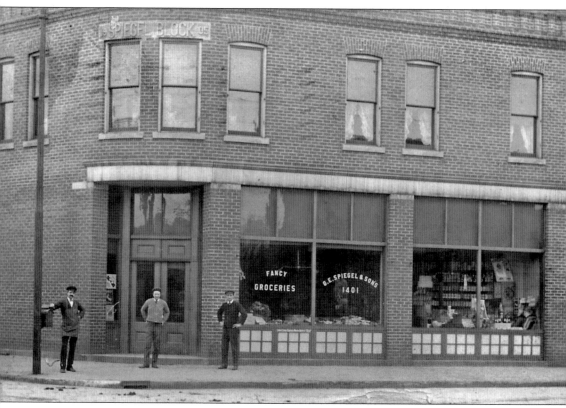

The rather successful-looking G.E. Spiegel grocery store at 1401 Broadway was owned by Gottfried Spiegel and was one of 168 Fort Wayne grocery stores listed in the 1910 city directory. While this building lives on to this day, none of the listed groceries are still in business. The two large regional grocery wholesalers in Fort Wayne of that era were G.E. Bursley and A.H. Perfect. Bursley, with its Elf brand, would later become part of Food Marketing Corporation and then, SuperValu. Both of these wholesalers would later come to supply the mid-century, locally owned chains Rogers, Scott's, and Maloley Brothers in addition to the smaller neighborhood independents. (Courtesy of Gene Branning.)

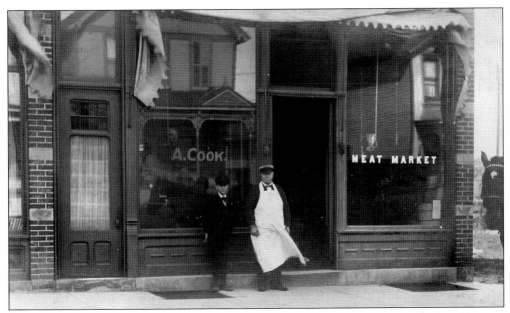

Lack of home refrigeration meant every neighborhood had its own meat market. Cook's Meat Market on Calhoun Street was one of 92 coexisting with Fort Wayne grocery stores in 1910. At that time, Peter Eckrich was a retailer and wholesaler on Lewis Street. With his five sons, his business would later grow into a major local corporation with over 1,000 employees; it is now owned by Smithfield Foods. (Courtesy of Todd Baron.)

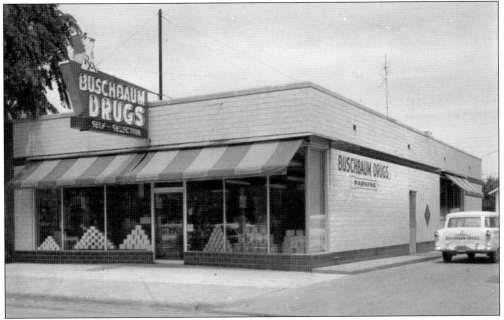

Like so many other drugstores featuring soda fountains during the 20th century, Bushbaum Drugs on East State Street was a neighborhood staple. The area's early leading drugstore chain was Meyer Brothers, founded in Fort Wayne in 1852. With eight locations, they were the city's largest purveyor of medications in the early 1900s. Years later, Keltsch Pharmacy would be the predominant hometown chain.

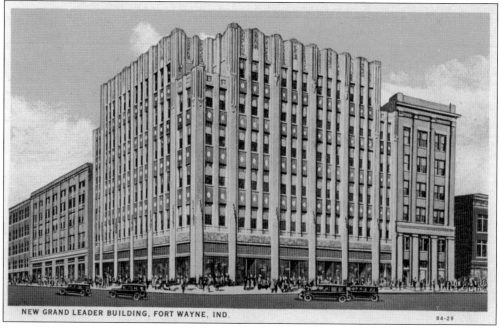

NEW GRAND LEADER BUILDING, FORT WAYNE, IND.

84-29

C-56

The immense Grand Leader department store sat on the southeast corner of South Calhoun and Wayne Streets. Largely destroyed in a December 1927 fire and rebuilt the next year, it was later renamed Stillman's, after the owner, J.K. Stillman of New York. Stillman's closed in 1974, and the property was sold to Indiana Michigan Power, which used the location for its One Summit Square headquarters and office building.

The longtime favorite downtown gift store Howard's, located on Wayne Street, would struggle before closing in 1986. However, the business had opened suburban sites, including stores at Northcrest Shopping Center in 1960, Glenbrook Mall in 1966, and the Pine Valley Mall in 1973.

74

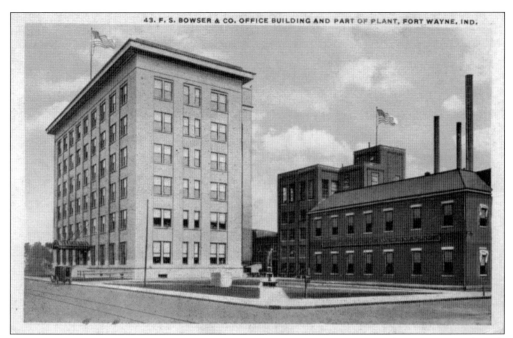

Founded in 1885 by Sylvanus Freelove Bowser, S.F. Bowser Company would revolutionize the oil- and gasoline-pump industry and employ over 1,000 people in the late 1920s. The tall headquarters building, opened in 1915 on West Creighton Avenue, would later become the offices of Phelps Dodge from 1966 to 1994, and would later house the Fort Wayne Police Department.

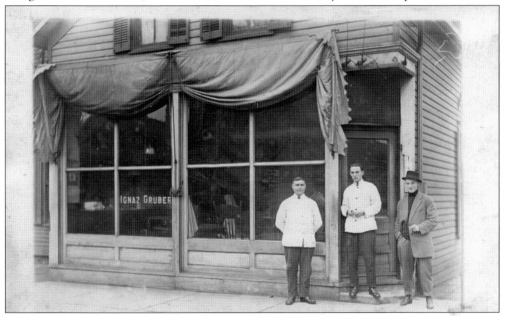

Ignaz Gruber's barbershop at 1812 Lafayette was typical of many in turn-of-the-century Fort Wayne, when the city had over 100 such establishments. Much of the business revolved around daily shaves with a straight razor rather than haircuts. Daily visits changed when the disposable razor was invented in 1901 by King Gillette and popularized when they were supplied to soldiers in World War I. (Courtesy of Jane Lyle.)

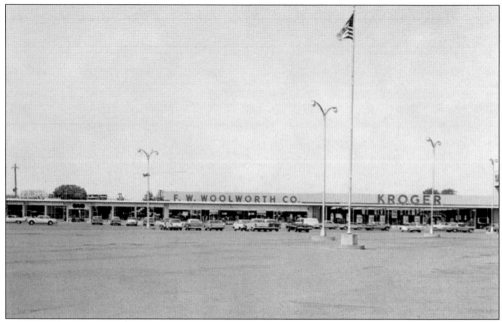

The retail flight to the suburbs began in earnest with the 1955 opening of Southgate, which boasted 40 stores and parking for 2,500 cars. Major early tenants included Stillman's, J.C. Penney, Kroger, Richmond Brothers, Peoples Trust Bank, W.T. Grant, and F.W. Woolworth.

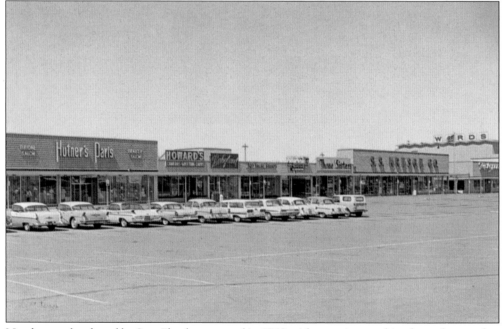

Northcrest, developed by Sam Fletcher, opened in 1960 with a spacious parking lot and stores that included both local and national chains. Those included Montgomery Ward, Kroger, Patterson-Fletcher, Howard's, F.W. Woolworth, W.T. Grant, Schlatter Hardware, Ream Steckbeck Paint, Schwartz Babyland, Three Sisters, Hutner's Paris, and Chen's Restaurant.

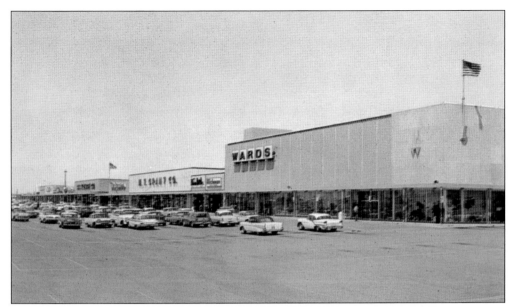

This is Northcrest shown from the opposite direction. Some of the city's other suburban shopping locations included Georgetown Square, which opened in the late 1960s with Rogers, Keltsch, Readers World, Franklin's, Lincoln Bank, and others, and Southtown Mall, which opened in 1969 with major tenants L.S. Ayres, Wards, and J.C. Penney's. In the 1990s, after years of struggles, Southtown was demolished and replaced by a Walmart and a Menards store.

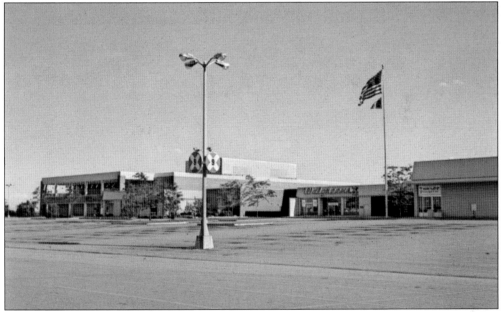

Glenbrook Mall was a showstopper when it opened in 1966 on Coliseum Boulevard, and it would expand further over the years. Featuring expansive parking, indoor shopping, and dining rolled into one, Glenbrook's early tenants included L.S. Ayres, Sears, Howard's, Cheers, Hutner's, Walgreens, Azar's, Fishman's, Hillman's, Meyers and McCarthy, King's A and I, Rustic Hutch, Hickory Farms, Kay, Bakers, Richmonds, Spencer, Indiana Bank, B. Dalton, Redwood and Ross, Nobbson, and dozens more.

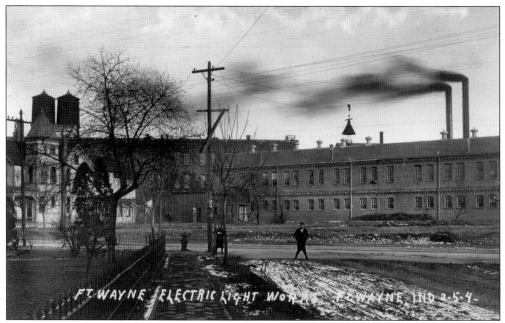

Fort Wayne's General Electric division began with James A. Jenny, the inventor of an electric arc lamp and small dynamo, who moved to the city in 1881 and opened up a small factory on the southwest corner of Calhoun and Superior Streets. Jenny Electric, later renamed the Fort Wayne Electric Company, moved in 1885 to Broadway. The company was absorbed in 1911 by General Electric. (Courtesy of Todd Baron.)

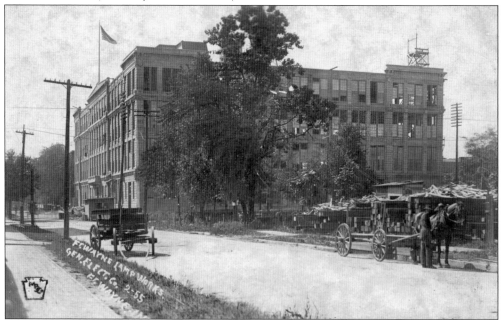

In Fort Wayne, General Electric would later make electric fans, refrigerators, garbage disposals, wire, generators, electric motors, transformers, and the airplane superchargers that would assist the country in winning World War II. Electric lamps were manufactured here at the Holman Street plant. This building would later become Fort Wayne Printing.

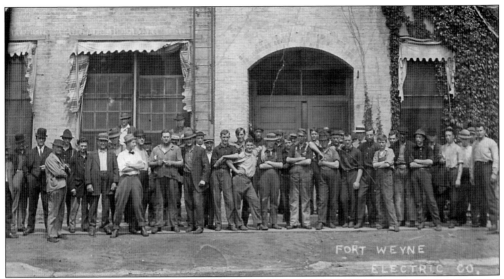

General Electric had several dozen buildings in Fort Wayne, including the major plants on Taylor, Holman, West Broadway, East Broadway, College, Wall, and Winter Streets. In the 1940s, it was the city's largest employer, with 20,000 men and women on the payroll. (Courtesy of Todd Baron.)

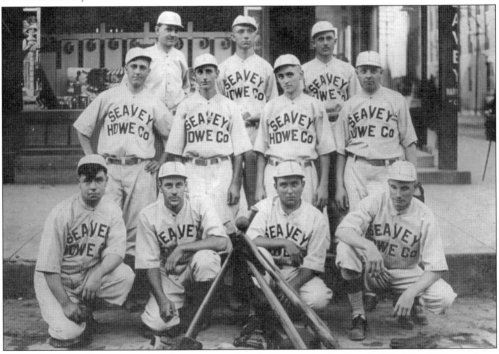

Many local employers sponsored a company baseball team in the first half of the 20th century. Examples were Lady Wayne Chocolates, General Electric, City Light, Centlivre and Berghoff Breweries, Pennsylvania Railroad, Allen Dairy, and Capehart-Farnsworth. Here, the Seavy Hardware team is pictured in front of the company offices at the northwest corner of Pearl and Harrison Streets. This building, still standing, is slated to be converted to apartments. (Courtesy of Todd Baron.)

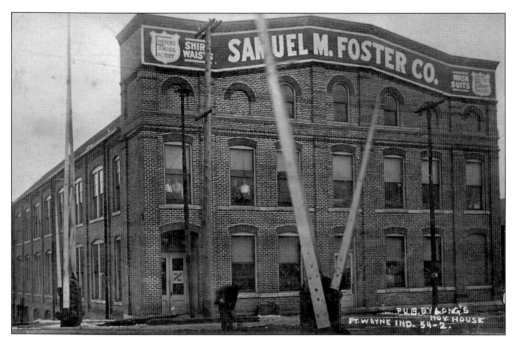

Samuel M. Foster Company, manufacturer of shirtwaists (women's collared blouses), was located at 417–423 East Columbia Street. Other one-time well-known area manufacturers that are now gone include Seyfert's, Fruehauf, Wayne Pump, Bowser Pump, International Harvester, Zollner, Capehart-Farnsworth, Magnavox, Wayne Candies, American Hoist & Derrick, Mobile Aerial Towers, Wayne Knitting, Bass Foundry, Centlivre and Berghoff Brewing, Eckrich, Horton, Parrot Packing, Rastetter, Kunkle Valve, and Tokheim. (Courtesy of Gene Branning.)

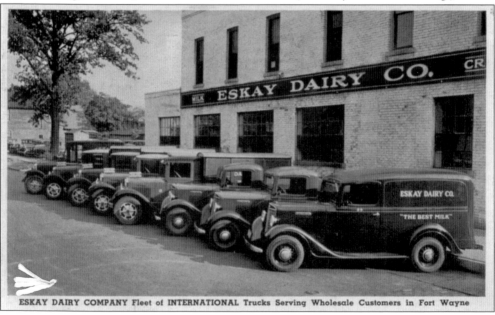

Eskay Dairy Company, located at 1501 Fairfield Avenue at Baker Street, was happy to show off its International Harvester delivery fleet in this c. 1925 postcard. Other Fort Wayne mid-century dairies included Allen, Flaugh, People's, Pure Sealed, and Tonne.

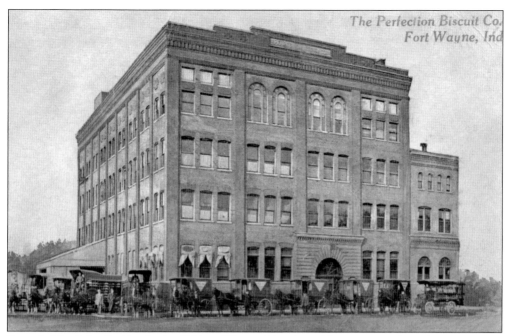

Founded by John B. Franke in 1901 as Wayne Biscuit and later renamed Perfection Biscuit Company, this substantial bakery, built on Pearl Street in 1904, offered bread, cookies, cake, and Franke's famous PW crackers. As a result of the renown of their primary brand of bread, the company was renamed Aunt Millie's Bakeries in 2005.

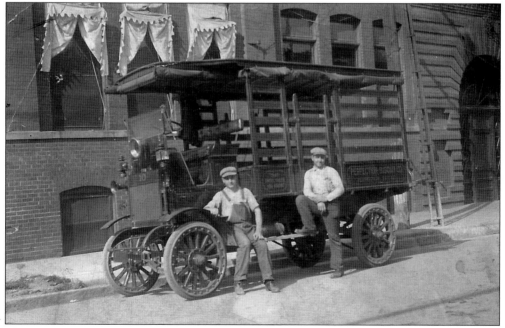

These Perfection deliverymen are seen in front of the southwest corner of the building. The main plant, much enlarged and still on Pearl Street, features the iconic Sunbeam Bread revolving sign that was installed in 1957 atop the building. Still family owned, Aunt Millie's now operates seven bakery plants in three states. (Courtesy of Gene Branning.)

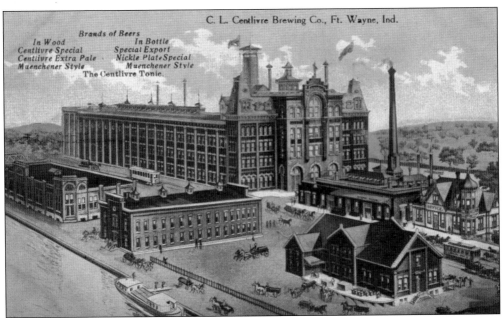

Charles Lewis Centlivre founded the Centlivre Brewery on Spy Run Avenue between the St. Joseph River and the feeder canal in 1862. Along with his sons Louis and Charles F., he built a thriving business that included a street-trolley line from downtown to the brewery and a park just north of the brewery that would include beer gardens and a racetrack. The park would serve as the city's circus grounds for many years.

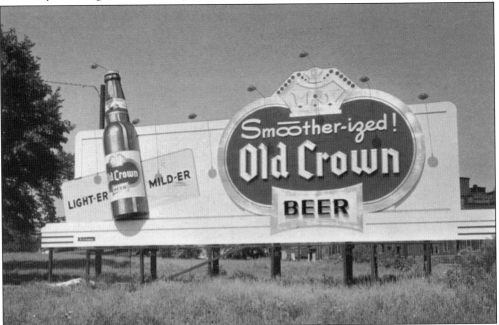

After merging with Chris-Craft, Centlivre was renamed Old Crown Brewery in 1961. Through the years, they produced (among other brands) Old Crown Ale, Alps Brau, Nickel Plate Special, Bohemia, Centlivre Tonic, and a near-beer called That's It. Never reaching the size and volume of the Berghoff Brewery across town, Old Crown closed in 1973 and has since been razed.

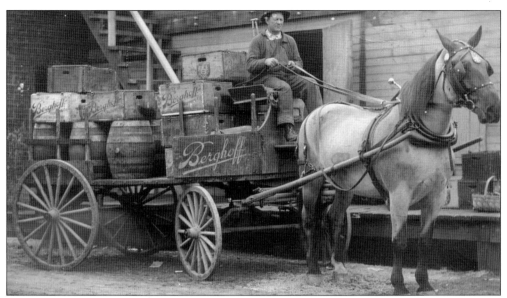

Berghoff Brewery opened on Grant Street in 1887, and during Prohibition bottled Bergo Soda. The family would become heavily involved in local politics, with one brother becoming mayor. In addition, the family developed other local business interests, including co-founding the German-American Bank and manufacturing concerns such as Wayne Home Equipment and Rub-No-More Soap Company. After selling Berghoff to Falstaff in 1954, they opened a competing brewery called Hoff-Brau. (Courtesy of Jane Lyle.)

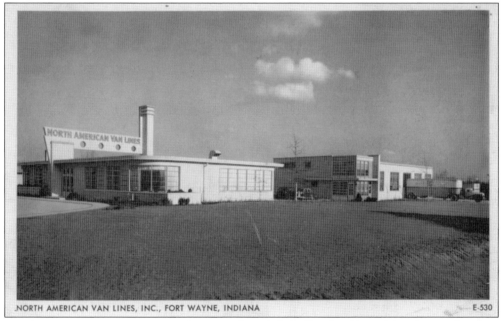

NORTH AMERICAN VAN LINES, INC., FORT WAYNE, INDIANA E-530

North American Van Lines, or NAVL, was founded in Cleveland in 1933 and moved to Fort Wayne in 1947. Sold to Pepsico in 1969 and to Norfolk-Southern in 1984, it merged with Allied Van Lines and was renamed SIRVA in 1999, becoming the world's largest moving company. Pictured are its old Streamline Art Deco offices on New Haven Avenue. In 1978, NAVL moved to a 121-acre campus on US 30 West.

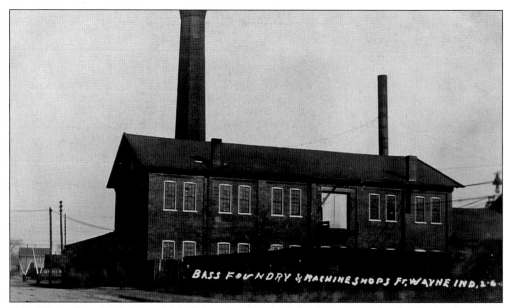

Fort Wayne Bass Foundry and Machine, founded by John Henry Bass in the 1850s, developed into the largest supplier of railroad wheels and axles in the country. Involved in many other local businesses, including the first horse-drawn streetcar company, Bass is likely best known today for the magnificent sandstone mansion built on Spring Street, now home to the University of St. Francis. (Courtesy of Todd Baron.)

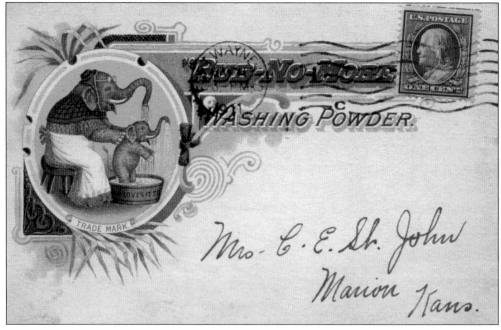

Summit City Soap Works, founded in 1880, was purchased in 1892 by Gustave A Berghoff (one of the four brothers of the Berghoff Brewery family). The company was renamed the Rub-No-More Company, and a large brick plant was built at the corner of Glasgow and Dwenger Avenues, where it still stands. The company, whose slogan was "Rub-No-More kills dirt," was sold to Procter & Gamble in the 1920s.

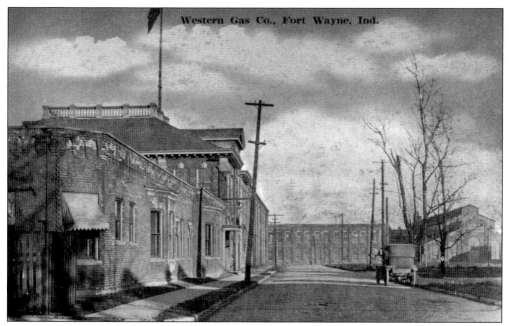

Western Gas Construction, a thriving manufacturer of gas valves and fittings and a builder of gas plants around the country, was founded in 1888 by Olaf N. Guldlin. Guldlin Playground at the St. Mary's River and Van Buren Street was named for his wife, Addie, an early advocate of children's playgrounds. The company, located at Winter Street and Holden Avenues, employed over 600 people before being sold in 1930.

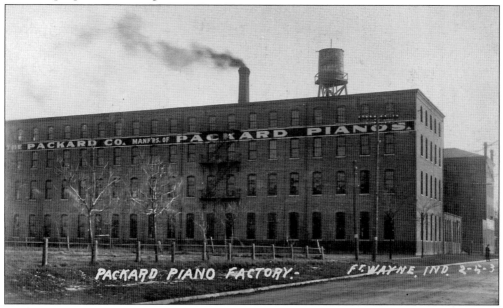

Founded in 1872 as Fort Wayne Organ Company by Isaac T. Packard, this factory sat at the corner of Fairfield and Organ Avenues (later renamed Kinsmoor Avenue). Manufacturing organs, pianos, and player pianos, the company also assisted in the war effort during World War I by making airplane propellers. At one time employing over 300 people, it closed in 1930 and the site became Packard Park in 1937. (Courtesy of Todd Baron.)

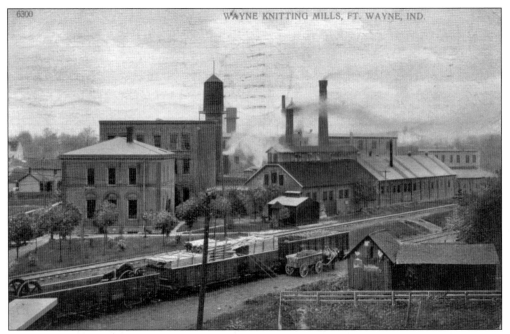

Established in 1891 at the northeast corner of Clinton and Main Streets (Friemann Square) by Theodore F. Thieme, Wayne Knitting Mills would become one of the city's largest and best-known turn-of-the-century employers. By the 1920s, there were 1,500 people—many of whom were women—working at this expansive factory at West Main Street and Knitters Avenue turning out seamless Wayne Knit Hosiery for women and pony socks for boys and girls.

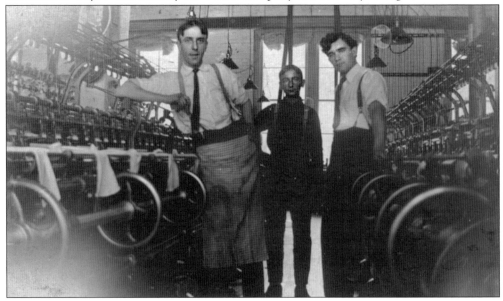

Thieme started the company by first importing both machinery and a handful of skilled workers from Germany. He took a very benevolent approach to his employees; the company had profit sharing, group insurance, a clubhouse, and dormitories to encourage women who did not live close by to work at the plant. Thieme also sponsored many employee athletic leagues and musical groups. The company was sold to Munsingwear of Minneapolis, Minnesota, in 1923.

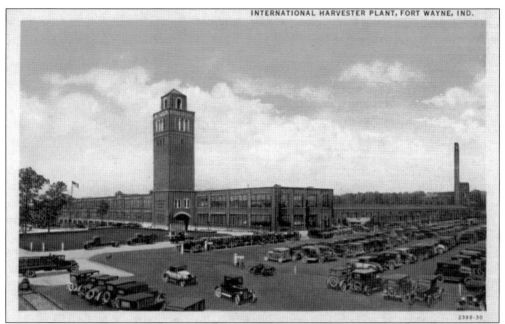

Few companies would have as much impact on Fort Wayne as International Harvester, which chose the city over 26 others vying for the plant. Construction began in 1922 at East Pontiac Street and Bueter Road. International Harvester became the city's largest employer and also attracted other companies to the east end area while continuing to vastly expand its own footprint.

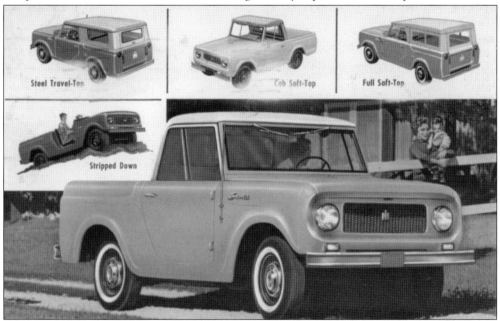

Steel Travel-Top

Cab Soft-Top

Full Soft-Top

Stripped Down

Between 1960 and 1980, more than 500,000 Scouts would be produced in buildings adjacent to International Harvester's main truck plant. The year 1963 was a milestone for the local plant when the one-millionth truck, a semitractor, rolled off the assembly line. At its peak, the Fort Wayne site employed nearly 11,000 people, but the city would lose its plant to Harvester's Springfield, Ohio, facility in 1983.

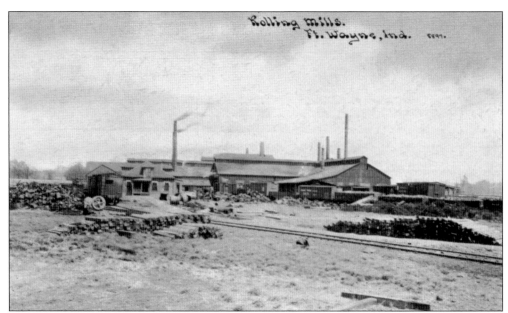

The Rolling Mills, founded in 1903 and originally staffed by 250 workmen from the Chicago area, grew to employ 600 at the Taylor Street plant just west of General Electric. In 1928, it was purchased by Joslyn Manufacturing, at which time a new electric steel furnace was installed and the company renamed Joslyn Stainless Steel. In 2004, Joslyn was acquired by Acciaierie Valbruna of Italy.

Louis Rastetter & Sons began operations manufacturing wood felloes for wagon wheels in 1881. They would later produce complete wheels, buggies, tennis rackets, wood steering wheels, and bicycles with wooden rims. When the 1920s card game Bridge became the craze, they started producing card-table sets and folding chairs from their Wall Street facilities; many of these sporting the brand name Solid Komfort can still be found.

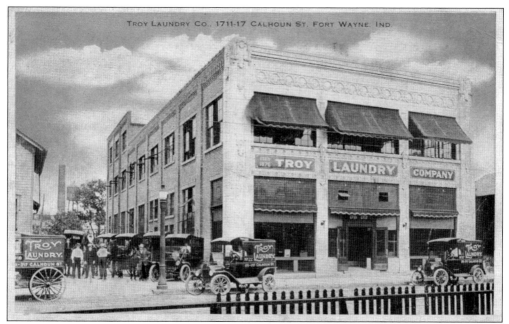

Founded in 1876, the Troy Laundry Company was originally located at 308–314 Pearl Street. In 1914, brothers-in-law Fremont L. Jones and Ogden Pierce would move the company into this substantial Beaux Arts style, terra-cotta facade building designed by Mahurin & Mahurin architects. Located at 1717 South Calhoun Street, the building stands to this day. (Courtesy of Jeanette Reitz.)

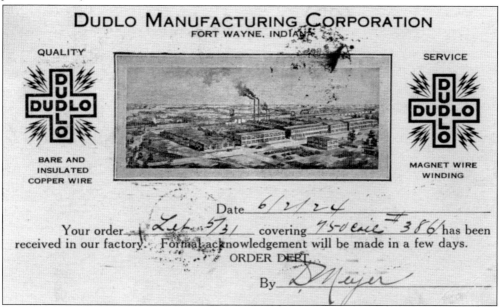

Dudlo Manufacturing started with George Jacobs perfecting the enameling of wire and moving the nascent company from Cleveland to Fort Wayne in 1911. Employing over 2,000 workers, Dudlo was sold to General Cable and became INCA; it later became part of ESSEX Wire. Contributing to the area's emergence as the wire-drawing capital of the world, former Dudlo president Victor Rea would go on to found Rea Magnet Wire.

The Wayne Crane was a product of American Steel Dredge Company located on Taylor Street across from the Rolling Mills. Beginning in 1909 with steam shovels and river dredges, they introduced the locally built, self-propelled cranes in 1942. Acquired by American Hoist & Derrick of St. Paul, Minnesota, in 1955, the Fort Wayne operations closed in 1983, and the parent company closed in 1985.

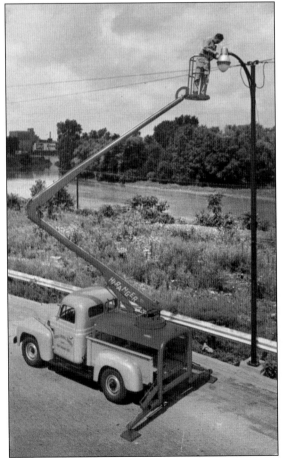

Mobile Aerial Towers, founded in the 1950s, utilized part of the old Bowser plant on Creighton Avenue to construct its truck-mounted insulated personnel lifts. Commonly known as cherry pickers, they were extensively used by power and telephone companies. The company, including its line of Hi-Ranger lifts, was sold to Hi-Ranger Inc. in 1982 and moved to Waukesha, Wisconsin.

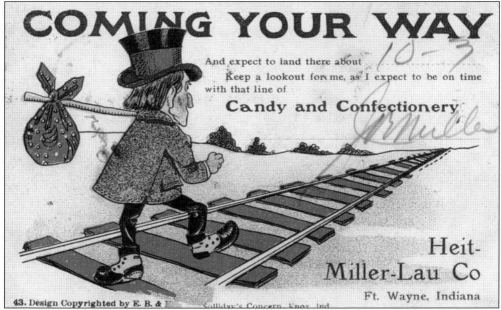

Route salesmen in the early 1900s would send customers a postcard reminding them of an impending visit. This card was sent by Heit–Miller–Lau, a local confections manufacturer founded in Fort Wayne in 1902. Renamed Wayne Candies in 1930, they were the makers of the famous Bun candy bar produced in the large brick plant at 1501 East Berry Street. The well-known vanilla, maple, and caramel Bun Bars are now made by Pearsons of St. Paul, Minnesota.

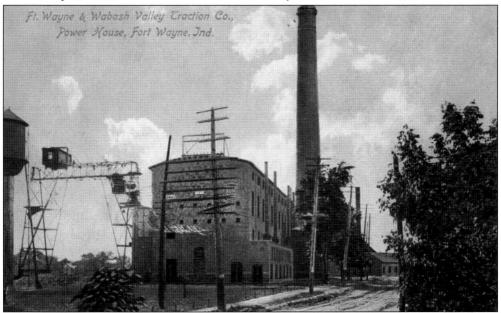

The Fort Wayne & Wabash Valley Traction Company powerhouse was completed in 1907 on Spy Run Avenue at Elizabeth Street. The concern became the Indiana Service Company in 1920 and would later change to Indiana & Michigan and, subsequently, American Electric Power. This powerhouse, which supplied electricity for the interurban and trolley lines as well as for much of the city of Fort Wayne, was torn down in 1963.

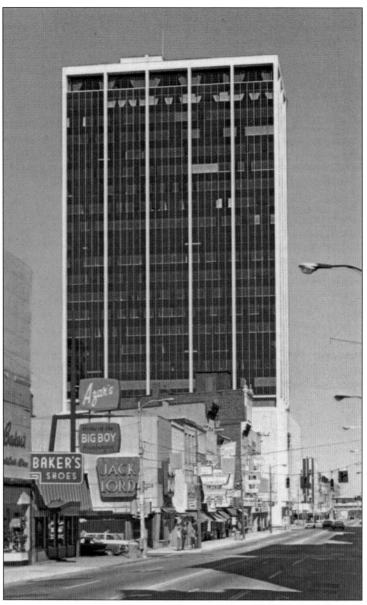

This shot looking north on Calhoun Street brings back many memories of downtown shopping in 1970 when the new Fort Wayne National Bank (now PNC) opened with its major tenant, Central Soya, and the exclusive Summit Club on the top two floors. Some of the well-known 20th-century retailers on and adjacent to Calhoun Street included shoe stores Baker, Hardy, Hanover, C and H, and Thom McAn. Clothing stores included Patterson-Fletcher, Fishman's, Saul's, Golden's, Richman Brothers, Hutner's Paris, and Meyers and McCarthy. Among the jewelry stores were Baber, Kay, Cousins, Bowers, Koerber, and Carl Rose. Department and five-and-dime stores were W&D's, Stillman's, Grand Leader, Woolworth, Neisner Brothers, Grant, and Murphy's. While downtown, one could eat breakfast, lunch, and dinner, get shoes repaired, go bowling, get a cavity filled, ponder getting a little painted turtle at the five and dime, buy a bicycle or car, have a hair appointment, pick out floor coverings, collect the dry cleaning, see a movie, and choose a few sweets at the candy store for the bus ride home.

Five

DISASTROUS DAYS

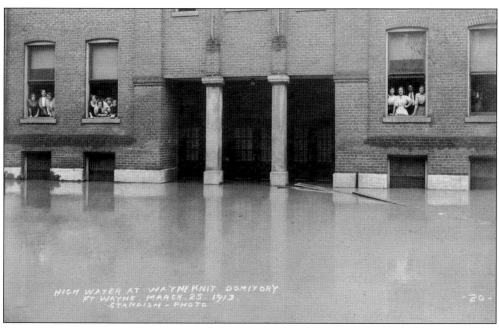

The worst flood in Fort Wayne's recorded history took place between March 23 and 27, 1913. When the rivers crested on Wednesday the 26th, the water was at 26.1 feet, well over the banks in many locations throughout the city. This postcard shows female employees trapped at the Wayne Knitting Mills Dormitory at West Main Street and Knitters Avenue. In all, 5,500 homes were flooded and incurred damage. Over 15,000 Fort Wayne citizens were made homeless, and all city schools were temporarily closed.

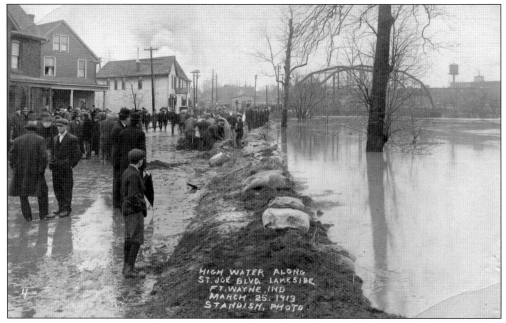

In this view looking south along St. Joe Boulevard, with the Columbia Street Bridge in the background, the flood had not yet crested, and the dikes continued to hold back the St. Joseph River. However, the next day—March 26—the Maumee River opened a 30-foot breech just east of the Coombs Street Bridge on Edgewater Avenue, and then the St. Joseph River opened several others here on St. Joe Boulevard.

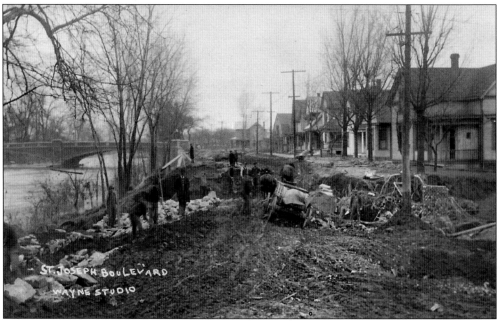

Like the image above, this photograph also depicts St. Joe Boulevard, this time looking north from Elmwood Avenue. This image is from after the flood and shows that the street has been washed out. In the background is the Tennessee Avenue Bridge, which had been completed the previous year, in 1912. (Courtesy of Todd Barron.)

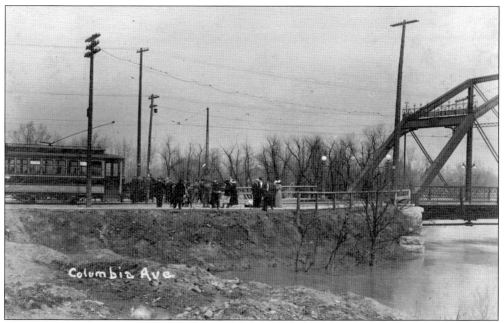

The town was brought to a complete standstill, as documented in this photograph with the electric trolley sitting on Columbia Street at the foot of the bridge. The Lakeside neighborhood ended up being flooded from St. Joe Boulevard to North Anthony Boulevard.

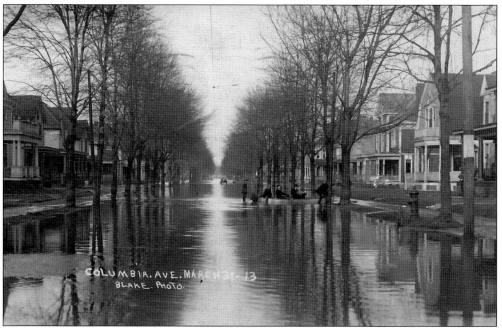

Even though the flood had crested five days earlier, this March 31 real-photo postcard looking east toward Lakeside Park shows there was still plenty of water on Columbia Street, as the men in the rowboat can attest. Large areas of the Lakeside, Nebraska, Bloomingdale, and Spy Run neighborhoods were under four feet of water. (Courtesy of Craig Leonard.)

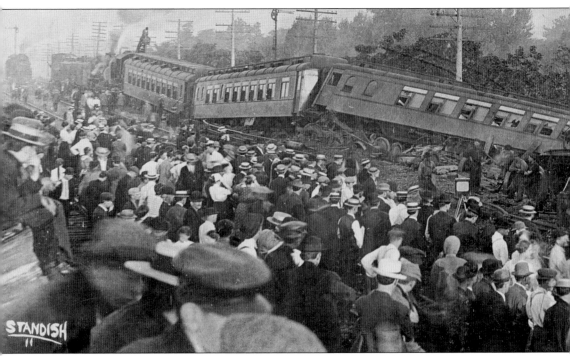

On the afternoon of August 13, 1911, the No. 28 Penn Flyer passenger train traveling from Chicago to New York via Fort Wayne was running late because of engine problems. One of the train's two Chicago locomotive engines failed as it was leaving Chicago and so was removed while still there. The remaining, overtaxed engine broke down near Plymouth, Indiana, and

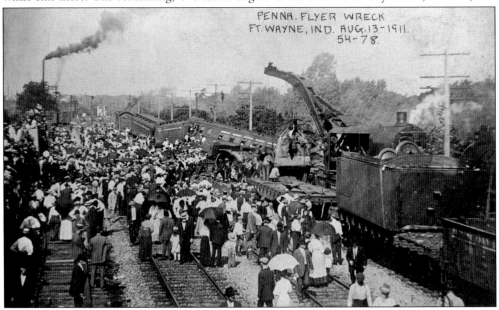

By the time the two new engines hooked on to the train at Winona, it was now an hour and a half late. To make up lost time, the train sped toward Fort Wayne. At a temporary track crossover, 400 feet east of the St. Mary's River Bridge at Swinney Park, with brakes applied and sparks flying, it crashed into an oncoming freight train.

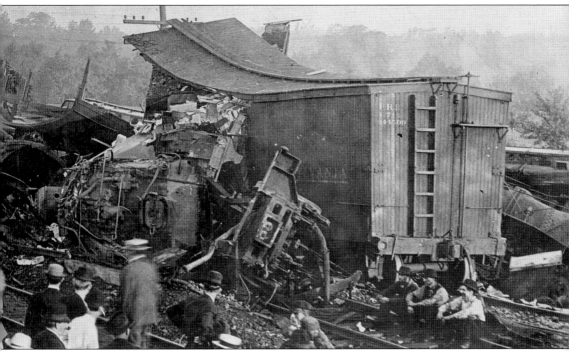

was replaced with a locomotive from a local train. In the meantime, in an attempt to try to get the passenger train back on schedule, two locomotives departed Fort Wayne and traveled west to meet up with and take over for the struggling No. 28 at Winona Lake.

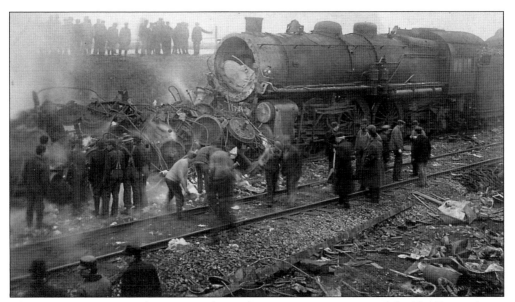

The passenger train, traveling at 50 miles per hour over a crossover rated for 10 miles per hour, and the freight train sustained damage that was beyond belief. Also horrific was the human wreckage, with four dead and another 35 injured. (Courtesy of Todd Baron.)

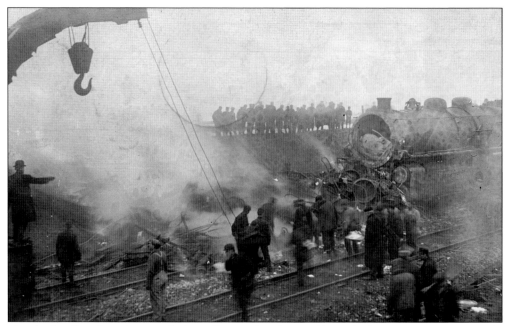

Hundreds of local residents took the Jefferson Shortline trolley, which ended at Swinney Park, to view the destruction. As for the passengers, some were taken to St. Joseph Hospital, some overnighted at the Anthony Hotel, and still others caught another train and, amazingly, arrived in New York City only five hours later than planned.

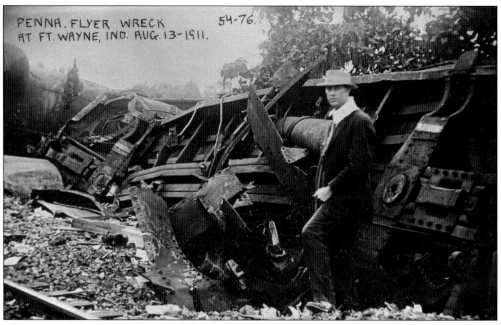

The main track and the track on which the freight train was sitting were torn up for a distance of 200 yards. If one stood at today's Swinney Park tennis courts and looked due south across Jefferson Boulevard to the railroad tracks, the view would be the accident's location.

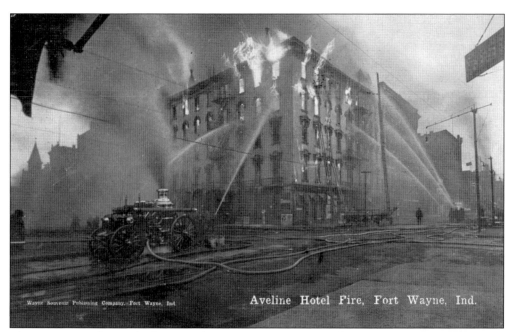

Aveline Hotel Fire, Fort Wayne, Ind.

The most tragic fire in the history of Fort Wayne took place at the Aveline Hotel, across the street from the courthouse at the southeast corner of Berry and Calhoun Streets, on May 3, 1908. The hotel, built by Francis S. Aveline in 1862, was widely considered at the time to be the city's finest.

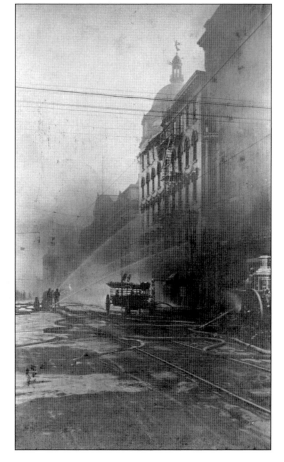

The fire was discovered at 3:30 a.m. on that Sunday morning when the night clerk saw a flash between the elevator doors, which was soon followed by blinding smoke throughout the building.

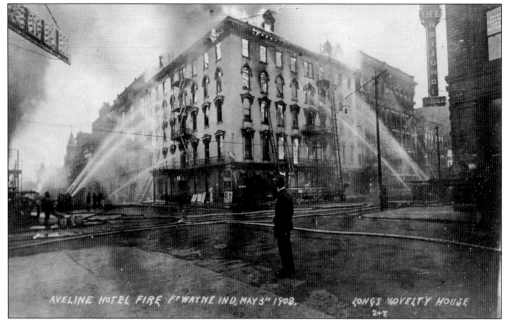

This was a night when an estimated 70 guests were staying at the hotel. Within minutes, the fire was being pulled up the elevator shaft from the basement, filling the hotel with a consuming inferno. Later investigation indicated the fire started in the elevator machinery.

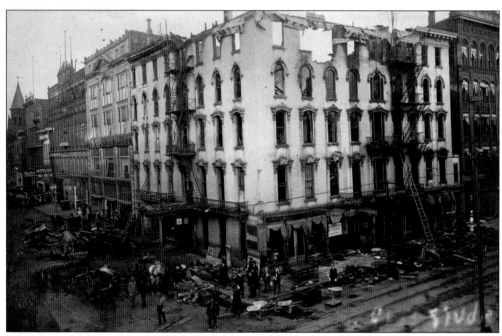

A dozen people died as a result of the fire. Some of the deaths and injuries were the result of people leaping from the roof and windows to escape the flames, only to be dashed on the sidewalks below. The Shoaff office building would be erected on the site of the hotel and would later be renamed the Gettle Building, which today is known as the Courtside Building.

Six

A Stroll around Town

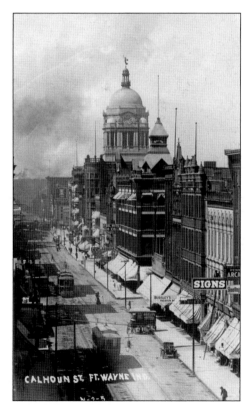

This c. 1908 view looking north on Calhoun Street was taken from the roof of the Indiana Furniture building at 1124 South Calhoun Street at Jefferson Boulevard. The near right buildings stand on what is now the site of the convention center parking garage. The building at center, Fox, Hite & Company, was later the location of W&D's from 1918 until 1959 and is now the location of One Summit Square. (Courtesy of Jane Lyle.)

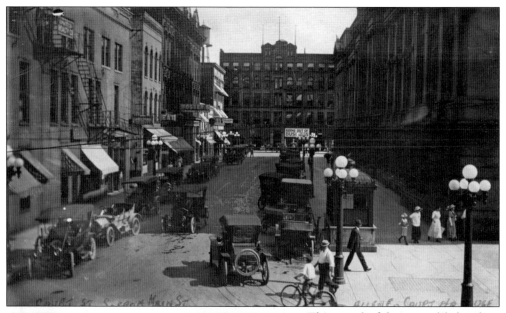

This wonderful picture, likely taken from a second-floor window, is from Main Street looking south down Court Street to the Pixley-Long Building on East Berry Street, which in 1930 became the site of the newly completed Lincoln Tower. As a result of the Courthouse Green project that was dedicated in 1999, the once-bustling block-long Court Street no longer exists. (Courtesy of Craig Leonard.)

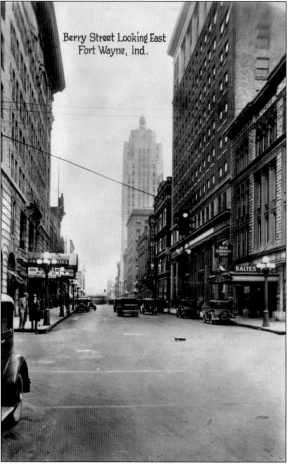

Taken around 1935 from the northwest corner of Harrison and Berry Streets (the site of today's Metro Building), this misty, eastward view down Berry Street shows, on the south side, the Baltes Hotel, Fort Wayne National Bank Building, and Sears Roebuck. In the next block is Lincoln National Bank and Trust. On the north side at the near corner is the 263-room Anthony Hotel.

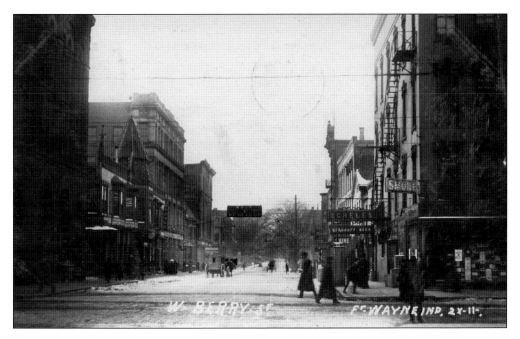

Looking west down Berry Street from the intersection of Calhoun Street on a cold and snowy day, this c. 1905 postcard shows the Arcade building at left. It would later be the site of Fort Wayne National Bank, whose building is now occupied by Star Bank. Below is a later image of the Arcade building taken in 1911 during the Indiana Gas Association convention at the Anthony Hotel, which was located across the street. The Arcade was turned into an exhibit hall with 60 exhibits showcasing displays of lights, machines, engines, water heaters, and appliances that could be run with natural gas.

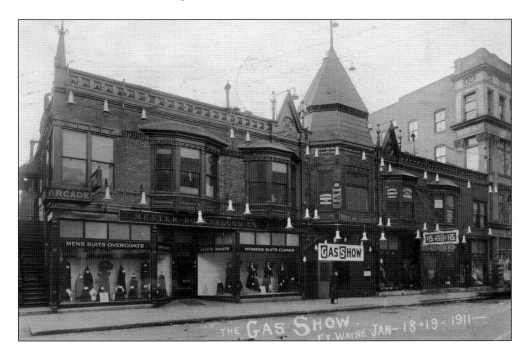

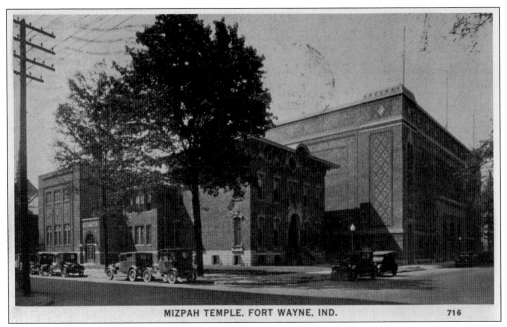

MIZPAH TEMPLE. FORT WAYNE. IND. 716

The Scottish Rite Center, designed by local architect Guy Mahurin, was completed in the fall of 1925. With a Moorish design, the large brick building belonging to the Mizpah Shrine was lost into receivership for a number of years and was renamed Quimby Auditorium. Regained by the Shrine, it was sold in 2012 to the University of St. Francis. Next door is the Olds mansion.

HOME OF THE TURN VEREIN VORWÄRTS
FORT WAYNE. IND.

In 1865, the German social club Turnverein Vorwärts, or Turners, opened a local chapter and later occupied this mansion built by Hugh McCulloch. The building, located at 1616 West Superior Street, had previously also been the home of the Fort Wayne Medical College. McCulloch, a former probate judge, was involved with several local banks and would later join the cabinets of Presidents Lincoln, Johnson, and Arthur as their secretary of the treasury.

Cathedral Square has its roots in a 35-by-65-foot log building called St. Augustine's, built in 1837 on the block bounded by Calhoun, Clinton, Jefferson, and Lewis Streets. The buildings in this view are, from left to right, St. Augustine's, constructed in 1846, the cathedral, completed in 1860, and Brothers School, also called Library Hall and later known as Central Catholic High School. (Courtesy of Jeanette Reitz.)

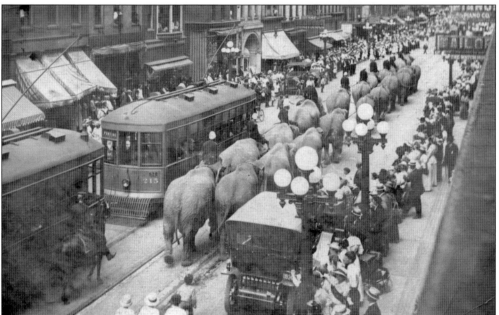

In this July 1913 photograph of the Sells Brothers Circus, the elephants are parading north down Calhoun Street on the block bounded by Washington and Wayne Streets. The circus grounds had several locations through the years, including the Headwaters Park area, then called the Jailhouse Flats; Centlivre Park, site of today's Centlivre Apartments on Spy Run Creek; and the area of Lakeside Park in its pre-park days.

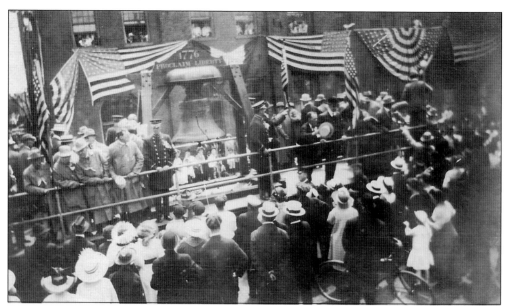

On its way from Philadelphia to San Francisco's Panama Pacific International Exposition in 1915, the Liberty Bell made a brief stop in Fort Wayne in front of the Olds Wagon Works on Murray Street, where it was viewed by an estimated 60,000 local residents. With his twice-daily aerobatics, Fort Wayne's pioneer aviator Art Smith would wow the massive crowds at the Exposition as well. (Courtesy of Todd Baron.)

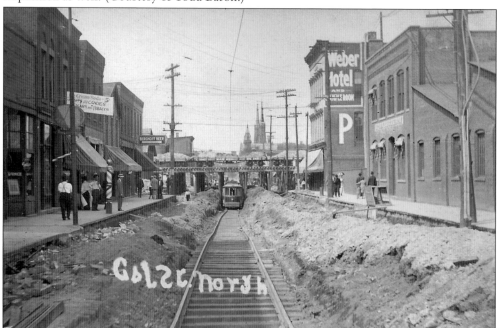

The years 1911 through 1913 saw both the Pennsylvania and the Wabash Railroad tracks being elevated through downtown Fort Wayne. This postcard view is of Calhoun Street looking north from around Murray Street. The Weber Hotel, at right, was at the foot of Grand Street at Calhoun Street. It would be over 40 years later, in 1955, before the Nickel Plate (Norfolk & Southern) tracks were elevated as well. (Courtesy of Craig Leonard.)

Art Smith, Fort Wayne's "Bird Boy," built his first airplane during the winter of 1910–1911. His first flight was from the Memorial Park area on Maumee Avenue to New Haven. In this 1911 picture, a crowd is admiring the then-novel airplane sitting in the infield of the Fort Wayne Driving Park, which was located just north of today's State Street and North Anthony Boulevard.

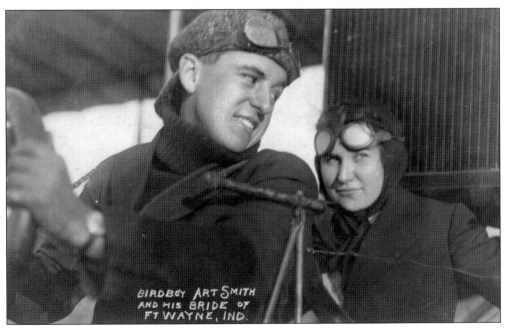

In 1912, Art and girlfriend Aimee Cour famously eloped by airplane to Hillsdale, Michigan, where they crash-landed and were then married in the hospital. In 1915, hired by the Panama Pacific International Exposition, Art would give twice-daily aerobatic exhibitions in San Francisco, further adding to his fame and renown. He crashed and was killed while flying for the US Mail Service during a snowstorm near Montpelier, Ohio, in 1926.

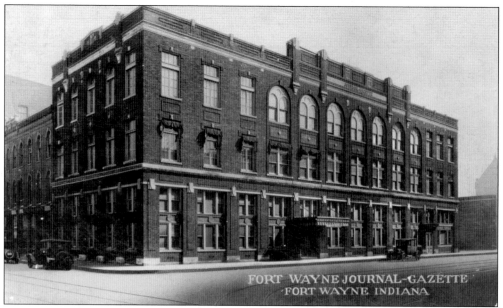

The *Journal Gazette*'s origins start with the 1899 founding of the *Fort Wayne Gazette*, which later merged with the *Journal*. Always privately owned, the paper's home office at the southeast corner of Main and Clinton Streets looks much the same in this postcard image as it does today. However, the paper, published by the Inskeep family, has since moved a half-mile west to 600 West Main Street. Its Sunday paper is the state's second largest.

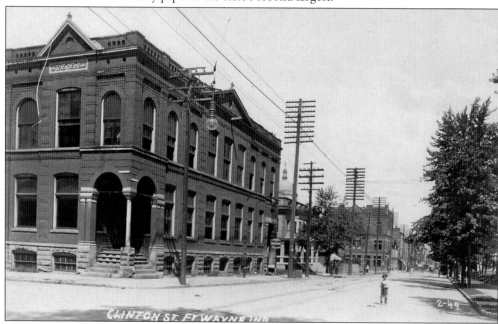

The *News-Sentinel* was formed out of the *Sentinel* (founded in 1833) and the *News* (founded in 1884, pictured); the paper's offices are now co-located (though the news and editorial offices remain independent) at 600 West Main Street in the Fort Wayne Newspapers building completed in 1958. The *News-Sentinel*, for many years owned by the Foellinger family, is now part of Ogden Newspapers of Wheeling, West Virginia. (Courtesy of Gene Branning.)

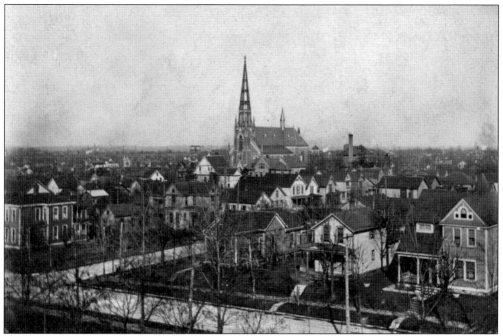

St. Peter's Catholic Church stands majestically on Dewald Street, viewed here from atop the Reservoir Hill. The city's fourth Catholic parish, it was a primarily German-speaking church. The first building of the complex was completed in 1872, and the church, begun in 1892, was designed in the Gothic style and dedicated in 1894. (Courtesy of Todd Baron.)

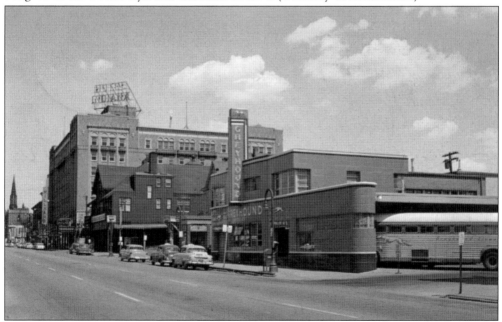

This beautiful Greyhound bus terminal, designed in the Art Moderne style, was located at 223 West Jefferson Boulevard between Harrison and Webster Streets. Built in 1938, it sat empty for a time before being razed in 1992. The Fort Wayne TinCaps stadium's Jefferson Street entrance now occupies this site.

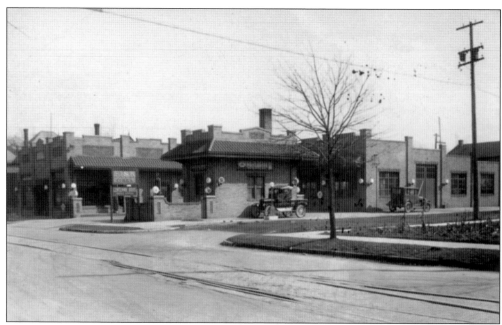

The Centlivre family was involved in several business ventures beyond their brewery and the Baker Street Centlivre Hotel. Three blocks east of the St. Joe River, at the southeast corner of State Street and Pleasant Avenue, sat this business—Centlivre Brothers Service Station. The main building still stands and is today's Deluxe Glass. (Courtesy of Gene Branning.)

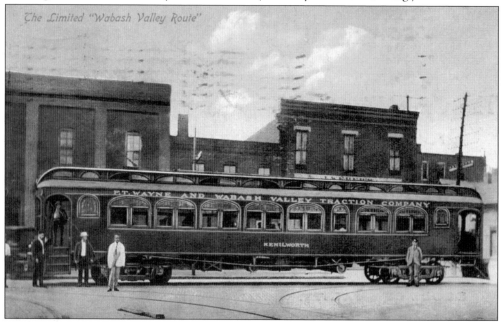

The Fort Wayne & Wabash Valley Traction Company terminal and yards took up the entire block in front of Perfection Bakery, bounded by Main, Pearl, Webster, and Ewing Streets. From this location, one could catch an interurban car and have access to several thousand miles of track throughout the state. The system reached its peak ridership in the 1920s, and the last interurban car rolled out of Fort Wayne in 1941.

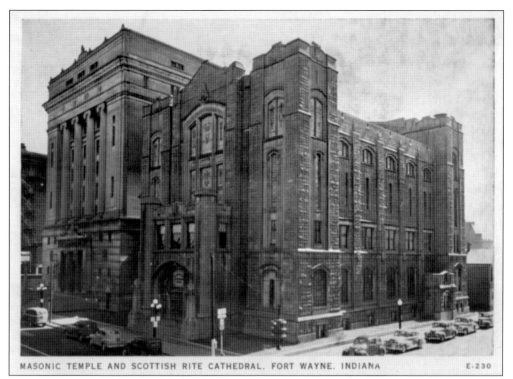

MASONIC TEMPLE AND SCOTTISH RITE CATHEDRAL, FORT WAYNE, INDIANA E-230

The Masonic Temple, also called the Freemasons Hall, and the Scottish Rite Cathedral sit side by side in the 200 block of East Washington Street in this c. 1930s postcard. The 10-story, Classic Revival temple designed by Charles A. Weatherhogg was completed in 1926. At one time, it was joined by a causeway to the Scottish Rite Cathedral, which was completed in 1924 and is shown at right. The Scottish Rite Cathedral was razed in 1960 and the site is now a parking lot.

St. Paul's Evangelical Lutheran Congregation on Barr Street is the second-oldest Lutheran church in Indiana. Replacing prior church buildings on this property, the structure pictured was completed in 1889. Sadly, it underwent a horrific fire in 1903 that nearly burned it to the ground. A new church, just like the original, was built at the same location and opened in 1905.

111

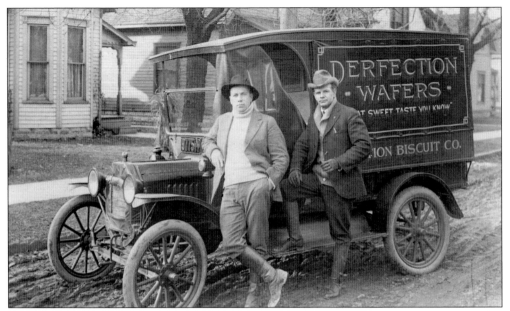

These two Perfection Biscuit deliverymen are pictured taking a break on a neighborhood's dirt street. While some of the downtown streets had earlier been paved with creosote-soaked wood Nicolson blocks and later, brick, it was not until Mayor Grice's administration (1909–1913) that brick paving was addressed in earnest, with 35 miles being completed. Some brick streets can still be seen in the West Central and Bloomingdale neighborhoods. (Courtesy of Todd Baron.)

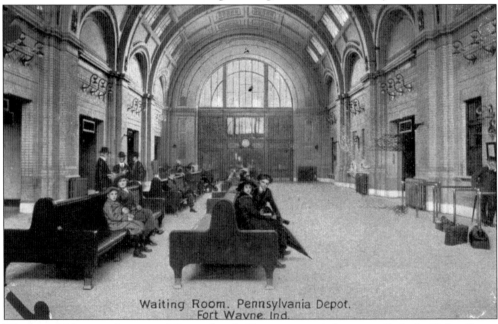

The beautiful, recently restored Pennsylvania Depot—or as it is now called, the Baker Street Station—was completed and opened to the public in 1914, when an estimated 10,000 people came to see the magnificent new structure. From 1945 through the 1950s, Santa would make his day-after-Thanksgiving arrival to Fort Wayne here and then make his way to his December home at Wolf & Dessauer's.

The first two trolley cars to operate in Fort Wayne were owned by the Citizens Street Railroad Company in 1872. By 1876, it had eight cars in regular scheduled service, all pulled by horses. The first electric trolley went into service in 1892, and the last electric trolley was run in Fort Wayne in 1947.

Trinity English Lutheran Church, founded in 1846, was the first English-speaking Lutheran congregation in the city. It was originally located on East Berry Street between Barr and Lafayette Streets in a building previously owned by the First Presbyterian Church. The bell from that building is still used by Trinity English today. Their second location, dedicated in 1864, was at Clinton and Wayne Streets. The present church at 405 West Wayne, dedicated in 1925, is a beautiful structure that encompasses the entire block.

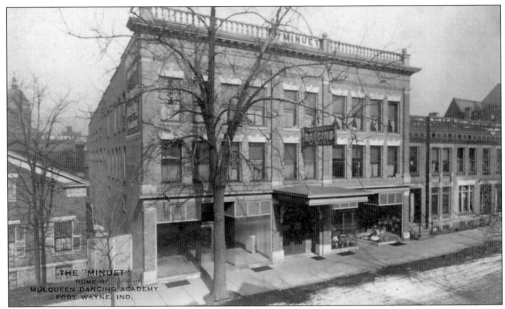

Dance instructor Estella Mulqueen and her pupil George Trier married and opened the dance pavilion at Robison Park in 1905. In 1911, they built the Minuet Building at 121 East Washington Street for their Trier School of Dance. Trier later leased West Swinney Park in 1920 and moved some rides and amusements from the closed Robison Park to the new Trier Park. Trier Park was destroyed by fire in 1953. (Courtesy of Craig Leonard.)

On Calhoun Street, the changing of the guard had begun. Pictured are two of the old electric trolleys and an electric bus that did not require the tracks. By the early 1940s, electric buses had completely taken over. By 1957, things changed again as the fleet had 59 of the electric buses in operation and 41 modern motor-driven buses. Shown at right is W&D's, and to its left, Peoples Trust Bank.

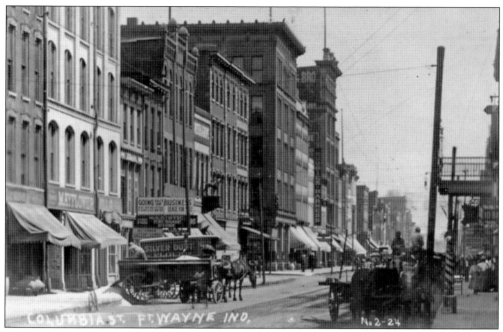

In 1908, the five-block-long Columbia Street was the city's primary wholesale and business district. The Landing Block is pictured here; Mayflower Mills, to the left, burned in a raging fire in May 1911, and across the street the barber pole stands in front of the Wayne Hotel (later renamed the Rosemarie), which suffered the same fate in 1975. (Courtesy of Craig Leonard.)

Pictured in front of a shoe store at 917 Maumee Avenue is a 1915 shuttle service that would pick up at outlying areas and deliver riders to Transfer Corner at Main and Calhoun Streets, where they could walk or catch trolleys to final destinations. The destinations for these ladies could have been the city's various knitting mills, as several thousand women worked at them in the early 1900s. (Courtesy of Jane Lyle.)

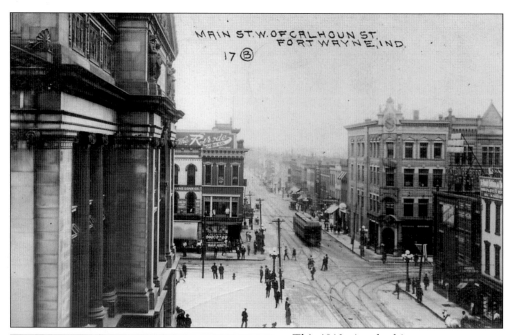

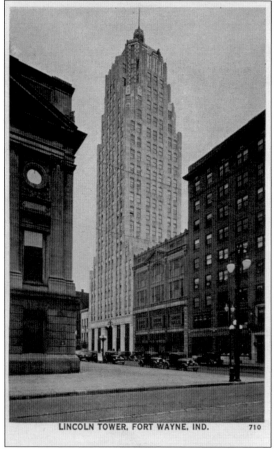

LINCOLN TOWER, FORT WAYNE, IND. 710

This 1913 view looking west on Main Street shows the intersection of Calhoun and Main Streets, which was known as Transfer Corner. Here, riders could have their tickets punched and take a different trolley to their final destination. In the 1870s, a turntable was located in the center of this intersection to allow the trolleys to turn. It was removed in 1888 when the curved tracks shown here were installed. (Courtesy of Craig Leonard.)

Lincoln National Bank and Trust, chartered as the German-American Bank in 1905, completed the impressive 22-story Art Deco Lincoln Tower in 1930; it would remain the state's tallest building until 1962. Lincoln Bank was purchased by Norwest Bank in 1993 and moved to Wayne and Calhoun Streets; in 2000, it merged with Wells Fargo. Since 1999, the Lincoln Tower has been home to the locally owned Tower Bank.

Moving from the 1893 building at Jefferson and Harrison Streets, the Congregational Church relocated into its fourth city location. The new structure, at the corner of Berry Street and Fairfield Avenue, was completed in 1924. Reincorporated in 1935, the church became Plymouth Congregational Church of Fort Wayne. In 2008, the congregation formally declared itself a Just Peace congregation of the United Church of Christ.

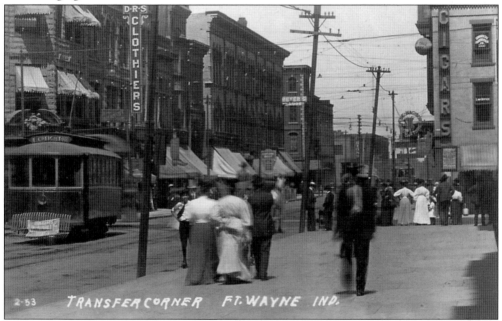

This view of Transfer Corner is looking north down Calhoun Street. The "Cigars" sign at right was Riegel's Cigar store, which Aloysius Riegel had purchased in 1905. With the impending construction of the City-County Building in the 1960s, all of the businesses bounded by Calhoun, Clinton, and Main Streets and the Norfolk & Western tracks were forced to close, or in the case of Riegel's, just move across the street. (Courtesy of Gene Branning.)

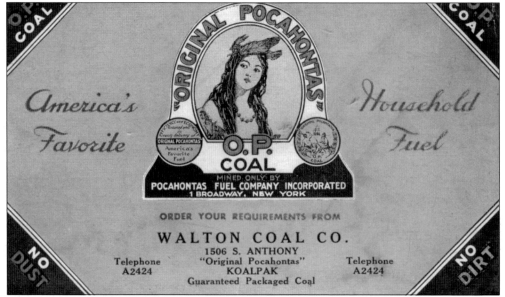

Coal was king for heating homes in 1920, with 30 local suppliers listed in the city directory. Walton Coal on South Anthony Boulevard at the Penn Central tracks offered the Original Pocahontas brand. At the turn of the century, Anthony Boulevard was called Walton Avenue and came to a dead end at State Street, which at the time was called Hicksville State Road. West of the St. Joe River, State Street was named Centlivre Boulevard.

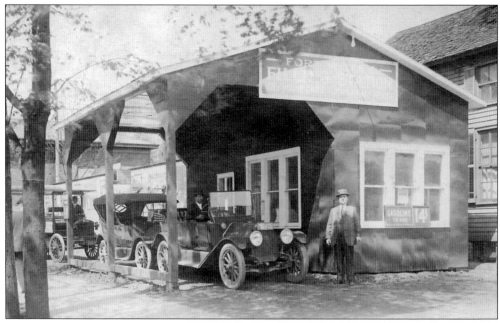

When the first automobile arrived in Fort Wayne in 1897, there was not a single paved street or gas station. However, it would not take many years for this to change. This 1914 postcard shows the Fort Wayne Filling Station at 142 Baker Street, where gas was 14¢ per gallon on the day this picture was taken. (Courtesy of Todd Baron.)

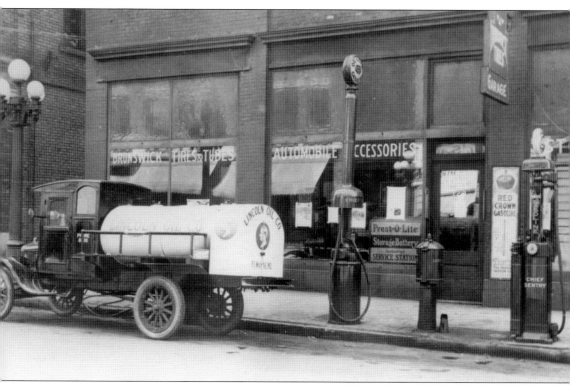

Lincoln Oil Company, located at 2103 East Wayne and owned by Amiel Gladieux, had several local filling stations in the 1920s and featured the Red Crown Gasoline brand in its pumps. Over the years, Fort Wayne would become home to three major gasoline-pump manufacturers. Founded in 1885, Bowser Pump, inventor of the Self-Measuring Pump, was located on Creighton Avenue and later moved to Chicago. Wayne Oil Tank Company (later renamed Wayne Pump), founded in 1891 and located on Tecumseh Street, made the first gas pump with a visible dial. In 1933, they devised the first computing pump, which gave the amount pumped and the cost. Now located in Austin, Texas, it is part of General Electric. Tokhiem was founded by John J. Tokhiem of Cedar Rapids, Iowa, whose plant came here in 1918 and moved into the old Wayne Spoke and Bending factory on Wabash Avenue. Tokhiem, the producer of the first visible pump (where gas was pumped into a glass globe and then fed by gravity into the car), is now one of the leading manufacturers of gasoline pumps in the world and is headquartered in Paris, France.

The pictured new station and terminal office for the Wabash Railroad was completed in April 1913 at Grand and Harrison Streets. Across the tracks, the Baker Street Station for the Penn Central Railroad would be completed a year later, in 1914. At one time, the two aforementioned railroads and the Nickel Plate Railroad all had passenger service to Fort Wayne. Since then, all passenger service has been discontinued. (Courtesy of Todd Baron.)

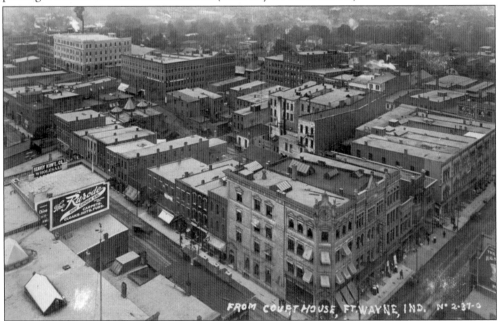

In this northwest view from the courthouse, the large white building at the extreme top left is Perfection Biscuit Company. The dark building just to the right of it is the Wayne Shoe Company/Seavy Hardware/Wayne Hardware building at Pearl and Harrison Streets, with the Randall Hotel to its right. At bottom right, the large corner building with awnings is the Hamilton National Bank, site of today's Salin Bank.

The Anthony Wayne Bank was founded in 1915 as the Fort Wayne Morris Plan with Theodore F. Thieme as president. The new building (pictured) was completed in 1961 at the northeast corner of Berry and Clinton Streets. The establishment later merged with Indiana Bank to become Summit Bank. This 15-story building, with four floors of indoor parking, is today being refurbished as AWB Luxury Condos.

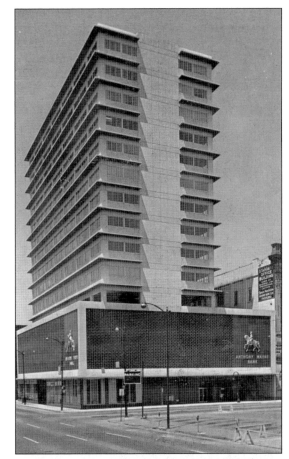

The nascent North Highlands housing addition is visible in the distance in this aerial view of Standard Lumber Supply on Leesburg Road between Spring and Main Streets. The empty field in the foreground is part of the University of Saint Francis and is now filled with classrooms, athletic facilities, and parking. (Courtesy of Craig Leonard.)

BROADWAY & TAYLOR STS. — FT. WAYNE, IND. 54-60

This 1912 view of the intersection of Taylor Street and Broadway shows the Meyer Brothers drugstore on the southwest corner, now the location of Mad Anthony Brewing. As now, it appears that residents would not have gone thirsty at this corner with its three taverns, two serving Centlivre refreshments and one serving Berghoff. (Courtesy of Todd Baron.)

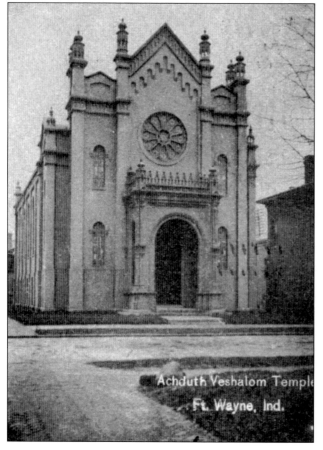

Achduth Veshalom Temple
Ft. Wayne, Ind.

Congregation Achduth Vesholom, the oldest Jewish congregation in Indiana, was founded in 1848 and held services in members' homes until the first temple building was dedicated in 1859. The second temple, which is pictured here, was dedicated in 1897 at Harrison and Wayne Streets. The third, erected in 1917, sat at the corner of Wayne Street and Fairfield Avenue. The congregation's current home at 5200 Old Mill Road was dedicated in 1961.

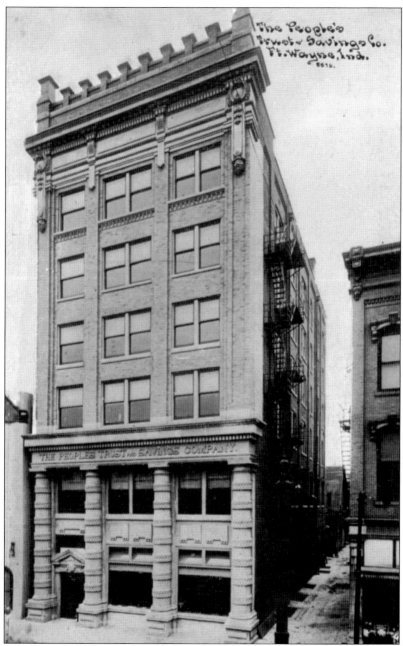

The venerable Peoples Trust Bank was located mid-block between Washington and Wayne Streets on the east side of Calhoun Street. Tucked between Grand Leader/Stillman's and W&D's, it, along with Lincoln National Bank, would be one of the only two local banks to survive the Depression without being reorganized. Known for its "Under the Clock" motto, the bank built the gold geodesic dome branch across from Northcrest Shopping Center and later added pyramid-shaped branches around town. Beginning in 1983, ownership changed several times, first to Summit Bank (the merged Indiana and Anthony Wayne Banks). The surviving remnants of Peoples Trust, Indiana, and Anthony Wayne Banks would finally become part of J.P. Morgan Chase. The large clock from the main branch was saved and re-erected in front of Baker Street Station in 2009.

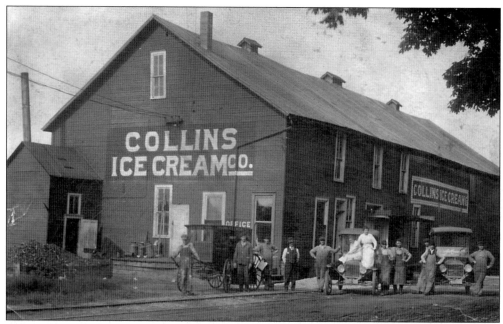

Collins Ice Cream Company, once located on Harrison Street, moved to Maiden Lane in 1909. However, the local ice-cream leader was the R.W. Furnas Ice Cream plant on Columbia Street near Clay Street. Headquartered in Indianapolis, Furnas was sold to Borden in the 1930s. With downtown redevelopment in 1963, Borden moved to a newly built factory on North Wells Street, which is now occupied by Edy's Ice Cream. (Courtesy of Gene Branning.)

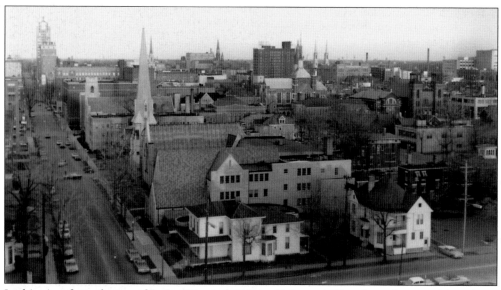

In this view from the top of St. Joe Hospital, Trinity Episcopal Church can be seen rising above its neighbors at 611 West Berry Street at the southwest corner of Berry and Fulton Streets. This historic Gothic Revival–style church, built of Indiana limestone and finished in 1866, was designed by noted Toledo architect Charles Crosby Miller. (Courtesy of Craig Leonard.)

The oldest continuously active congregation in the city, First Presbyterian Church, moved from its location at the corner of Washington and Clinton Streets to the new brick, Colonial-style building at 300 West Wayne Street in 1956. In 1957, the Washington Street location would become home to Indiana Bank and the city parking garage.

Beautiful Lindenwood Cemetery, located on West Main Street, opened in 1860 on what had once been swamp and scrub lands. Listed in the National Register of Historic Places, it today has 175 rolling acres of landscaped, wooded property. Many of Fort Wayne's notable pioneer families and civic leaders are interred here. A stroll through the beautiful grounds reveals the sources of many of the city's street, park, building, and business names.

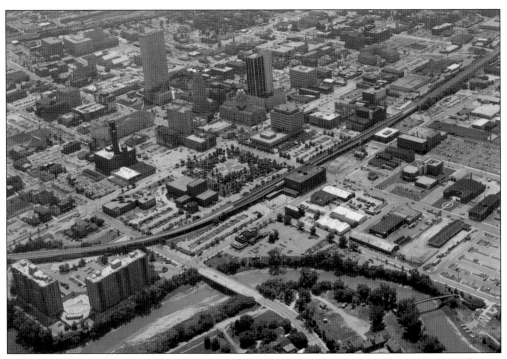

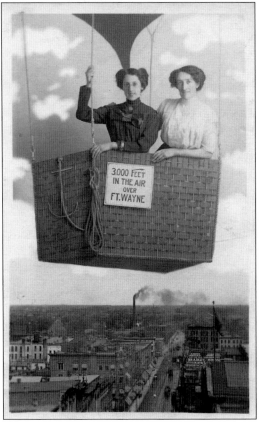

This c. 1970 aerial postcard image of Fort Wayne shows the newly constructed, 14-story Three Rivers Apartments building at lower left with its uniquely shaped swimming pool that first welcomed residents in 1967. The high-rise, luxury apartments were erected on what was once the 400 block of East Columbia Street, which had previously housed Pettit Storage, Furnas Ice Cream, Foster Shirtwaist, Brinkman Sign, the Banner Laundry, and the A.H. Perfect Company.

While this c. 1910 farcical photography-studio balloon launch never actually got off the ground, Fort Wayne's first real balloon ascension had actually successfully taken place in front of a cheering crowd 50 years earlier on August 30, 1859, at the intersection of Barr and Main Streets.

BIBLIOGRAPHY

Allen County Photo Album 1852–1954. Fort Wayne, IN: *News-Sentinel*, 2008.

Allen County Photo Album 1955–1959. Fort Wayne, IN: *News-Sentinel*, 2009.

Ankenbruck, John. *Twentieth Century History of Fort Wayne.* Fort Wayne, IN: Twentieth Century Historical Fort Wayne Inc., 1975.

Beatty, John D. *Historical Sources of Fort Wayne, Indiana.* Fort Wayne, IN: Allen County Public Library, 2000.

Beatty, John D. and Phyllis Robb. *History of Fort Wayne and Allen County.* 2 vols. Evansville, IN: M.T. Publishing Company Inc., 2006.

Bicentennial Heritage Trail Committee. *On the Heritage Trail.* Fort Wayne, IN: ARCH Inc., 1994.

Bradley, George K. *Fort Wayne's Trolleys.* Chicago: Owen Davies, 1963.

Bushnell, Scott M. *Historic Photos of Fort Wayne.* Nashville, TN: Turner Publishing Company, 2007.

Griswold, B.J. *The Pictorial History of Fort Wayne, Indiana.* 2 vols. Chicago: Robert O. Law Company, 1917.

Hawfield, Michael C. *Fort Wayne Cityscapes.* Northridge, CA: Windsor Publications, 1988.

Mather, George R. *The Best of Fort Wayne.* vol. 1. St. Louis, MO: G. Bradley Publishing Inc., 2000.

Mather, George R. *The Best of Fort Wayne.* vol. 2. St. Louis, MO: G. Bradley Publishing Inc., 2001.

Pfeffenberger, Dyne L. *The Historic Fort Wayne Embassy Theatre.* Bloomington, IN: Quarry Books of Indiana University Press, 2009.

Roberts, Rachel Sherwood. *Art Smith: Pioneer Aviator.* Jefferson, NC: McFarland & Company Inc., 2003.

Smith, Jason T. *Celebrate Fort Wayne: A Bicentennial Pictorial History of Fort Wayne.* Marceline, MO: Walsworth Publishing Company, 1993.

DISCOVER THOUSANDS OF LOCAL HISTORY BOOKS
FEATURING MILLIONS OF VINTAGE IMAGES

Arcadia Publishing, the leading local history publisher in the United States, is committed to making history accessible and meaningful through publishing books that celebrate and preserve the heritage of America's people and places.

Find more books like this at
www.arcadiapublishing.com

Search for your hometown history, your old stomping grounds, and even your favorite sports team.

Consistent with our mission to preserve history on a local level, this book was printed in South Carolina on American-made paper and manufactured entirely in the United States. Products carrying the accredited Forest Stewardship Council (FSC) label are printed on 100 percent FSC-certified paper.

MADE IN THE USA